Timeless

Film Photographs

By Richard Gallup

All the images in this book were produced with film in a darkroom between 1976 and 2006.

Also by the Author:

Makin' Art

A Street Artist's Story

By Rick Gallup

Timeless

©2015 Richard Gallup

All rights reserved

Marmalade Publishing

ISBN 978-0-578-16085-6

Listen

This book is about images, not words. Photographs are just another form of communication. Listen to them.

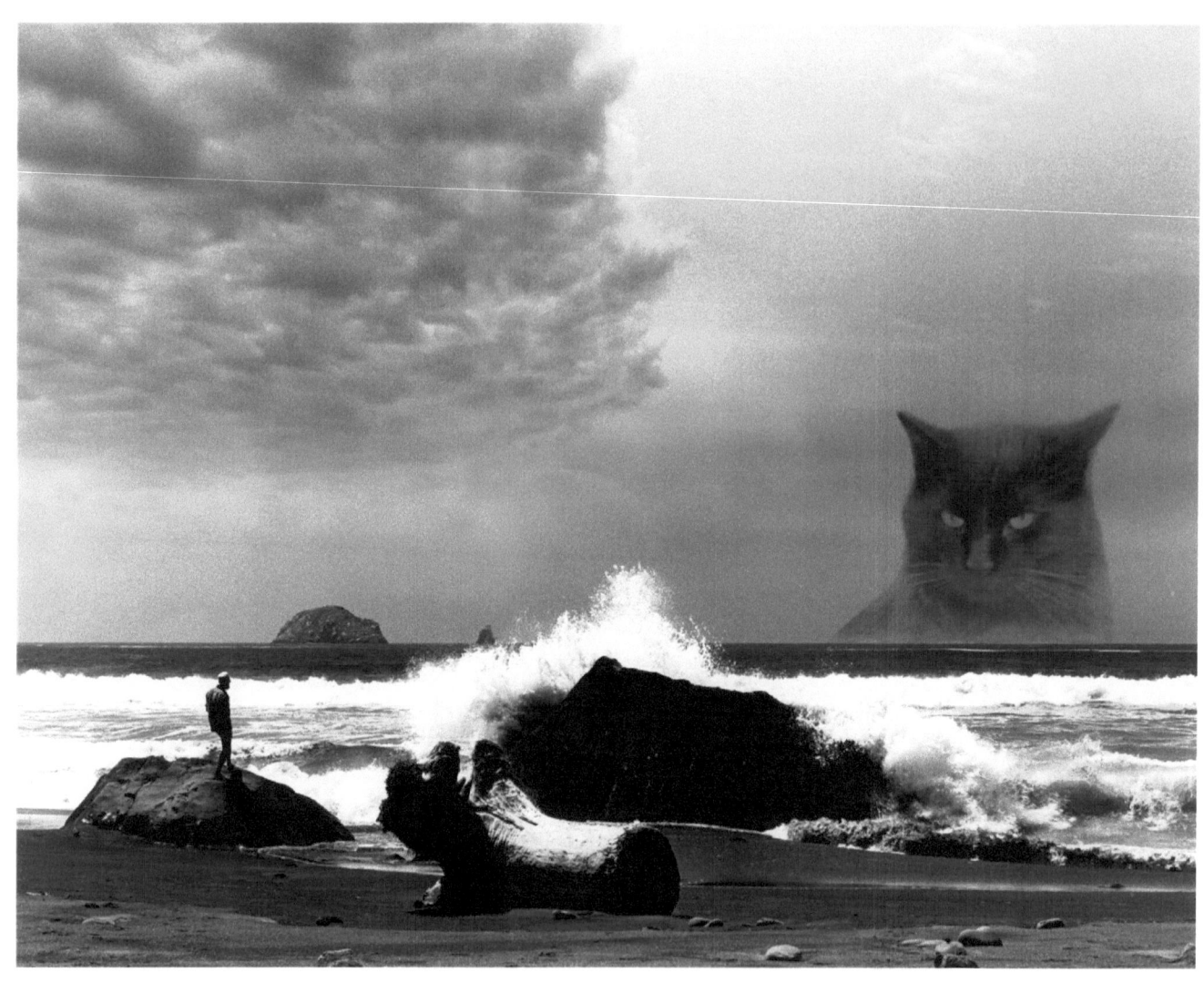

On The Horizon

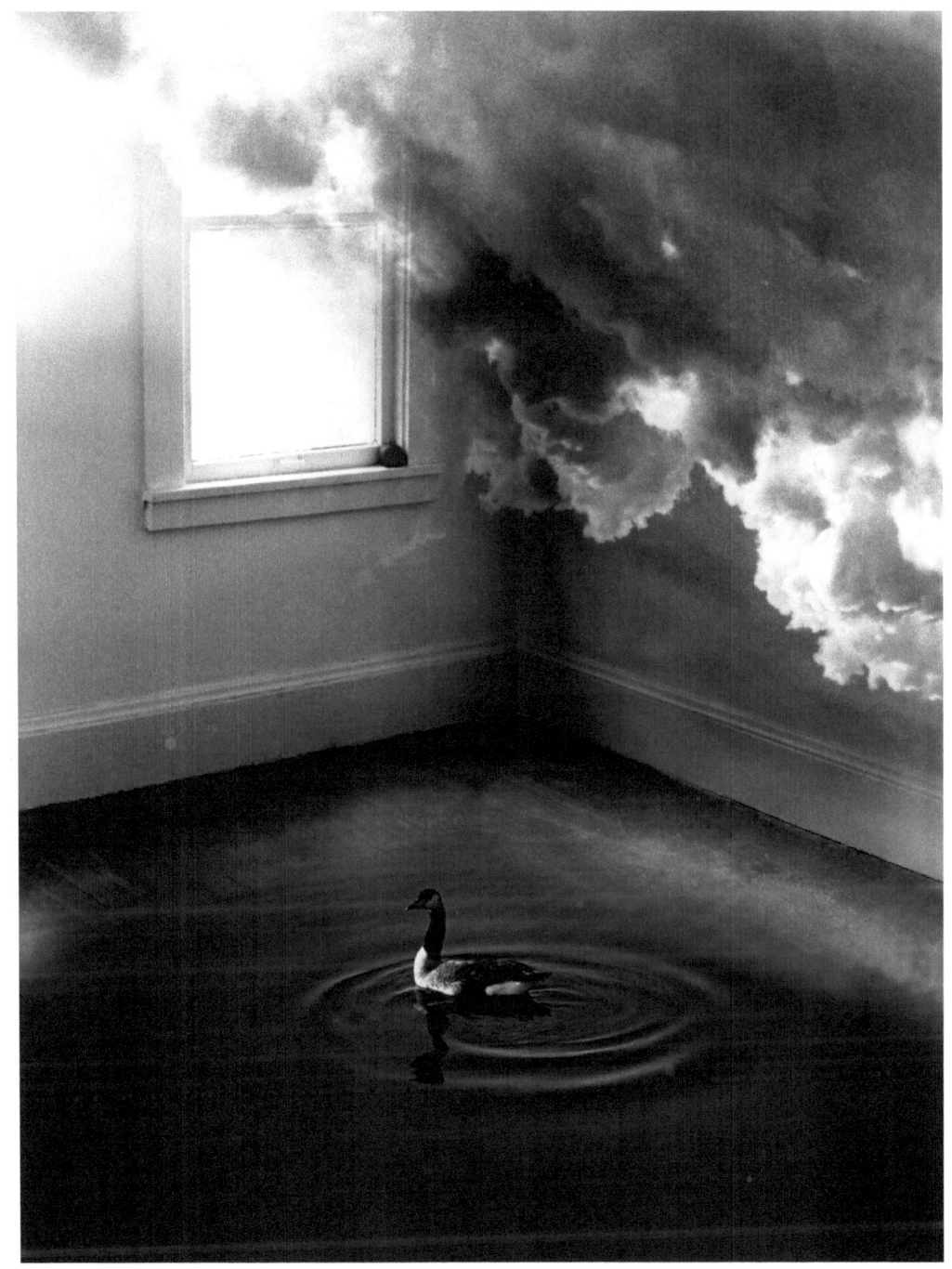

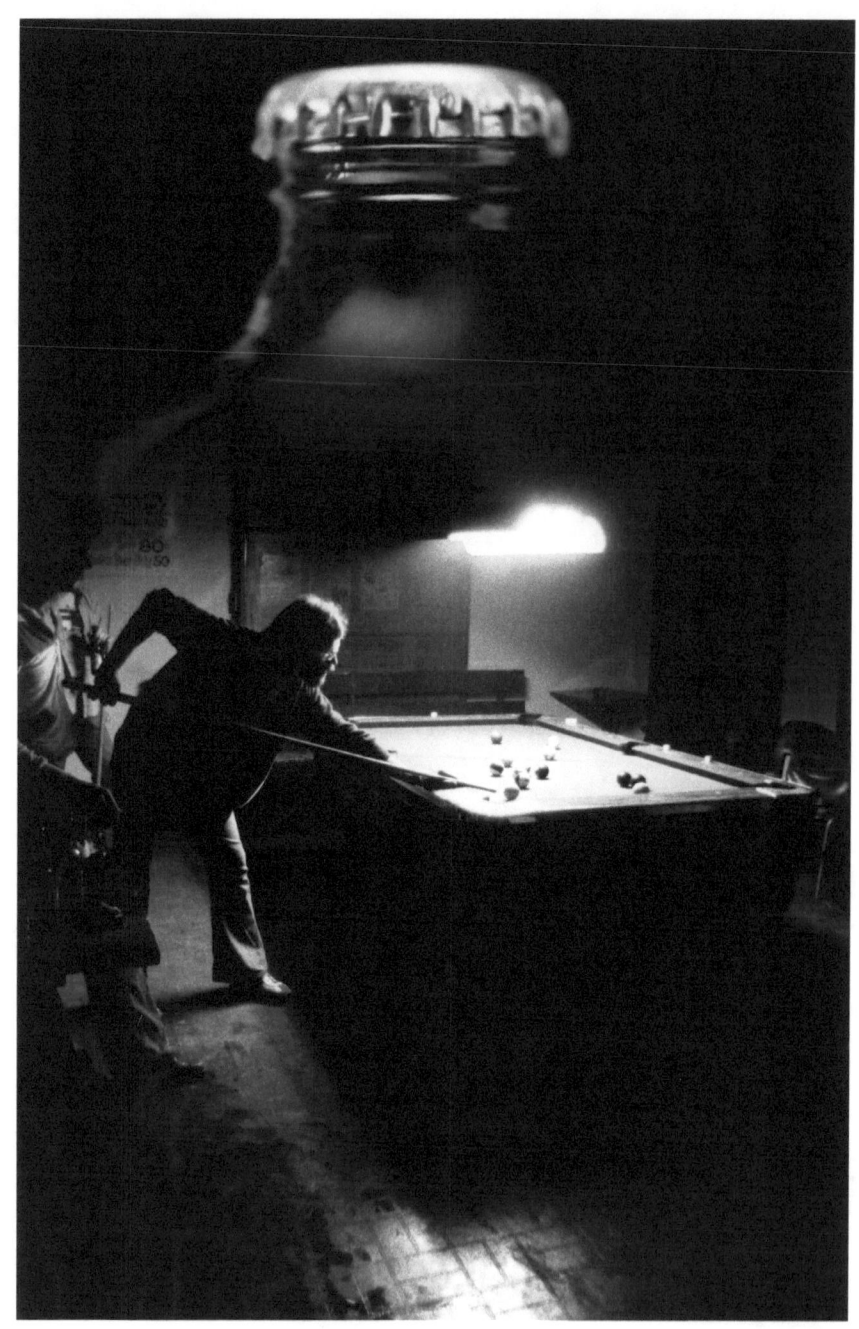

Bottled Blues

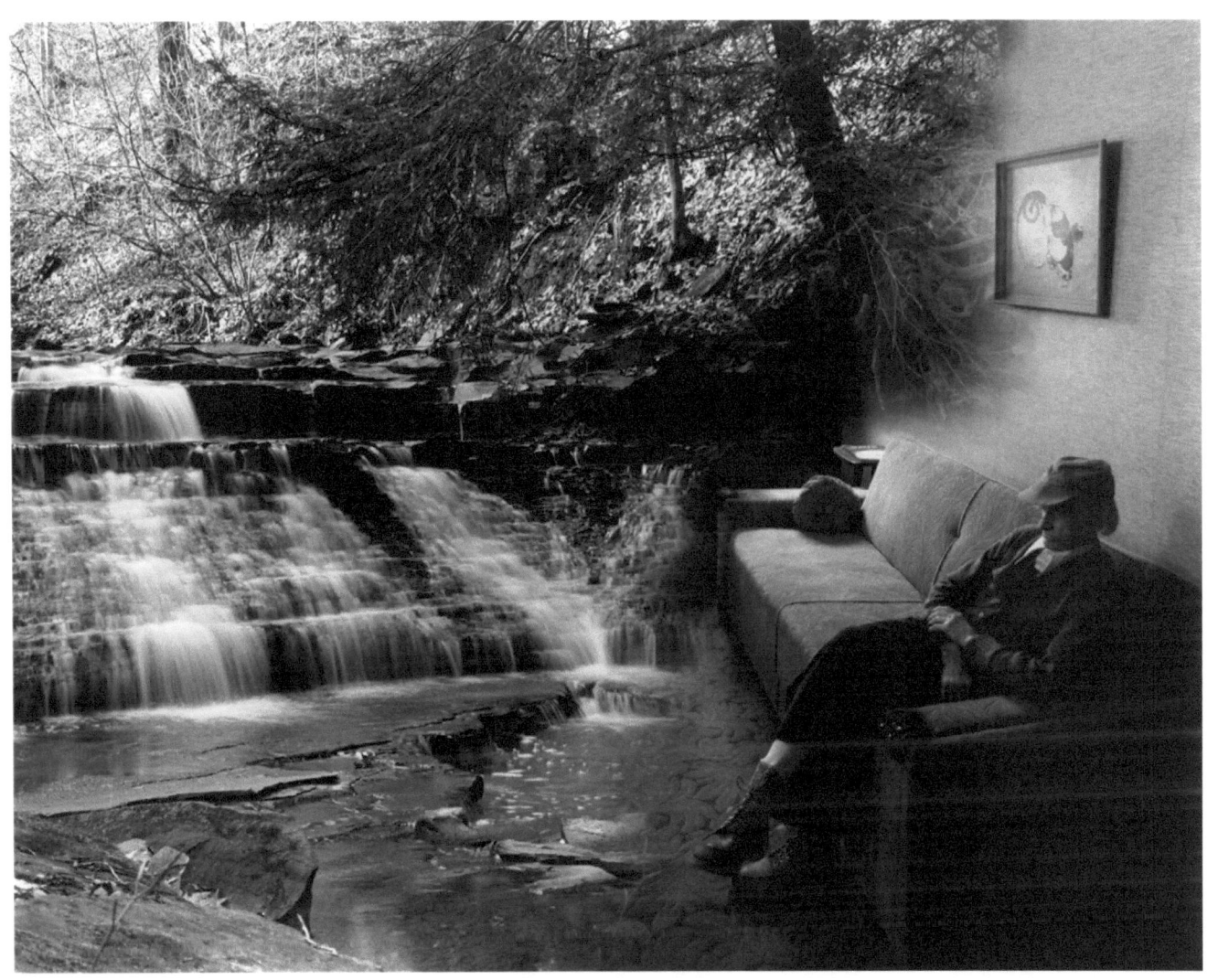

At Peace

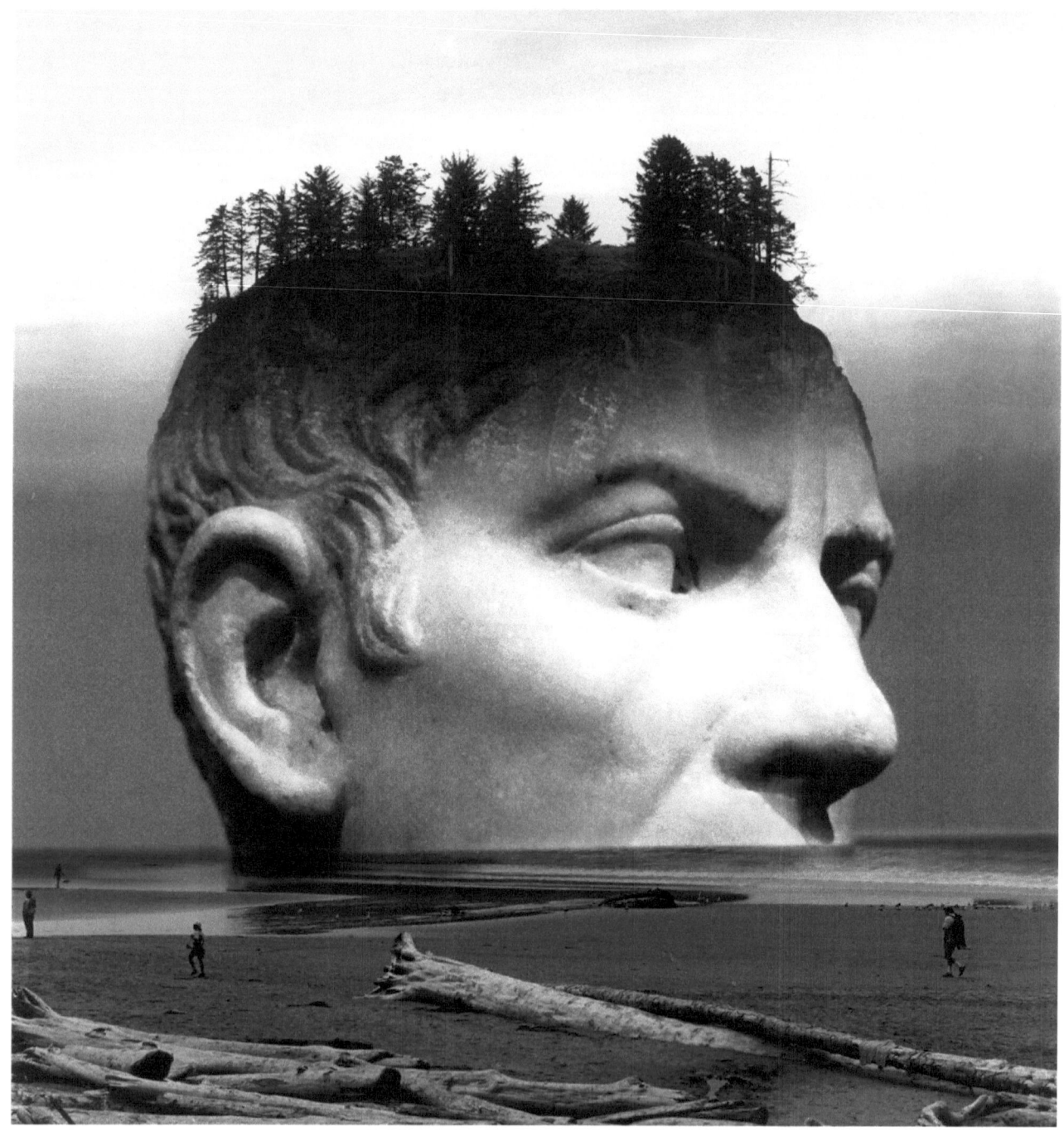

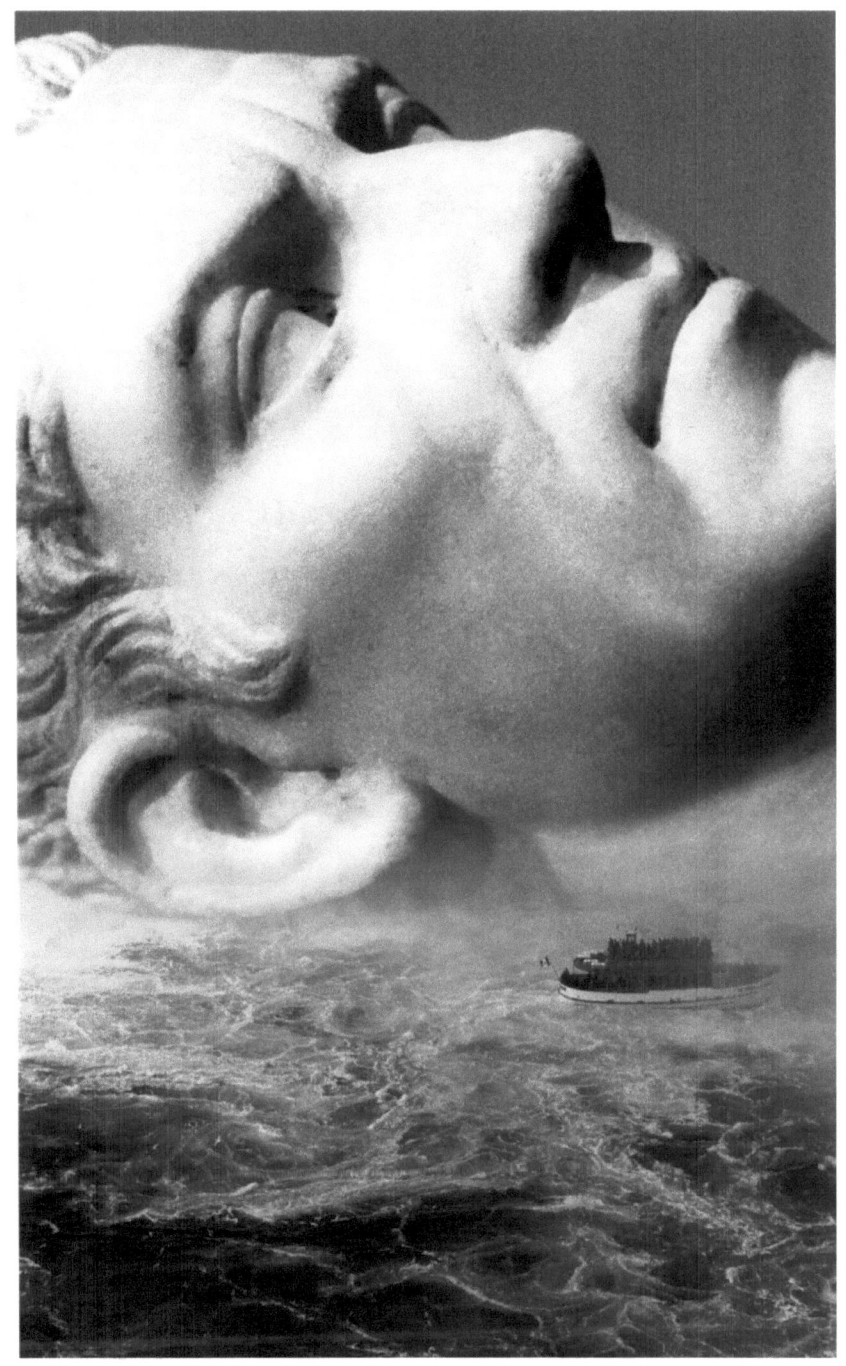

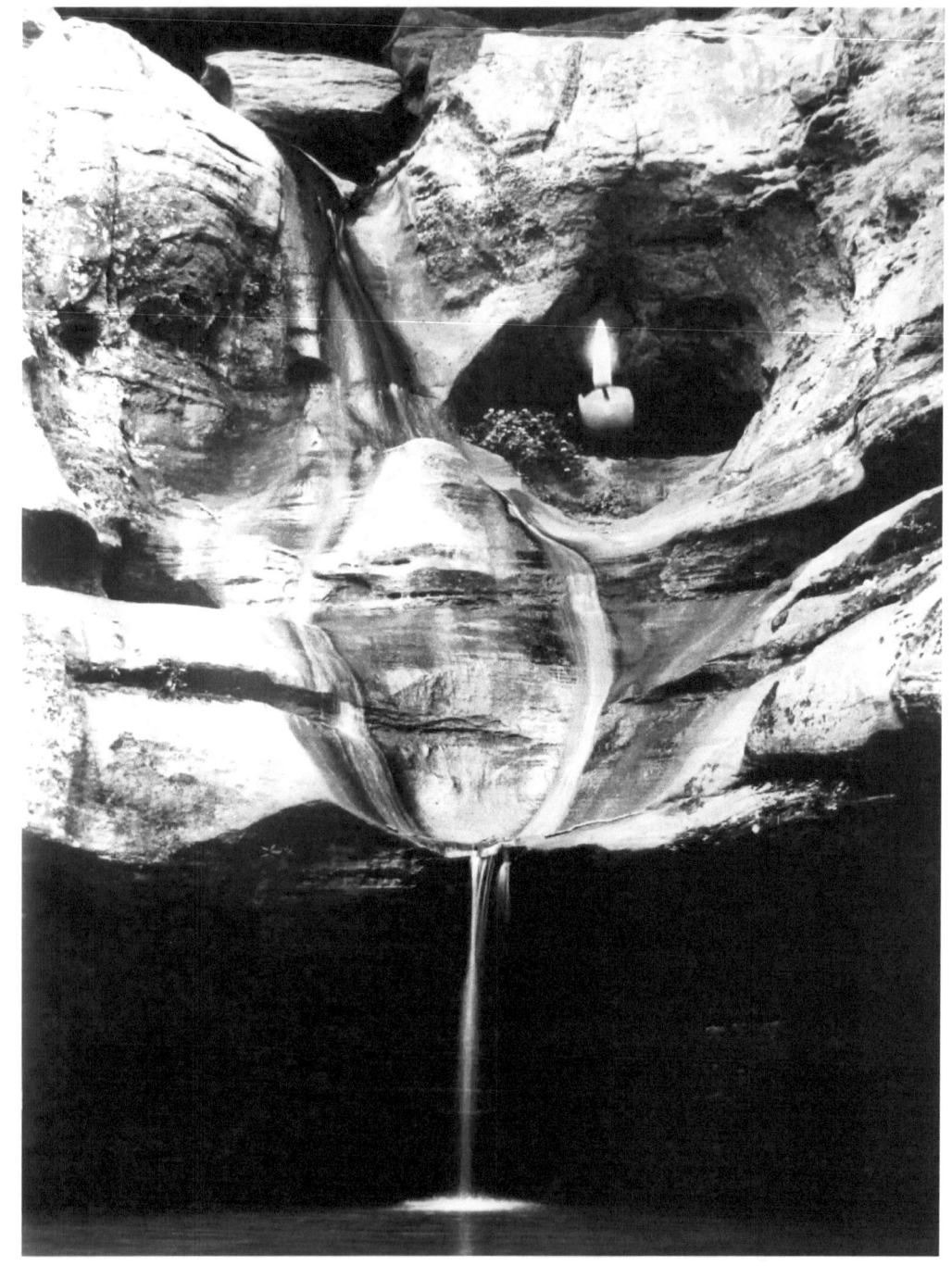

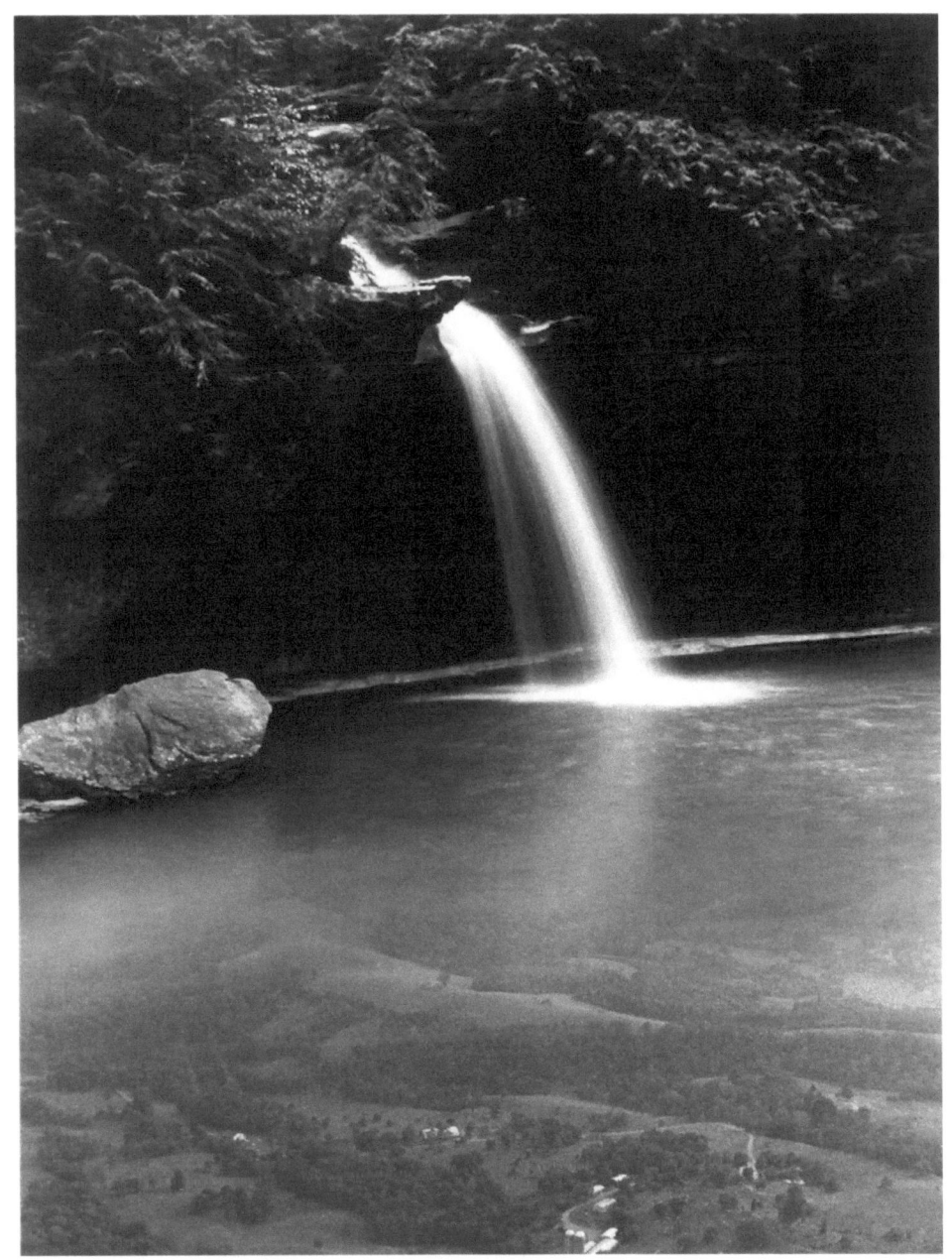

Liliput

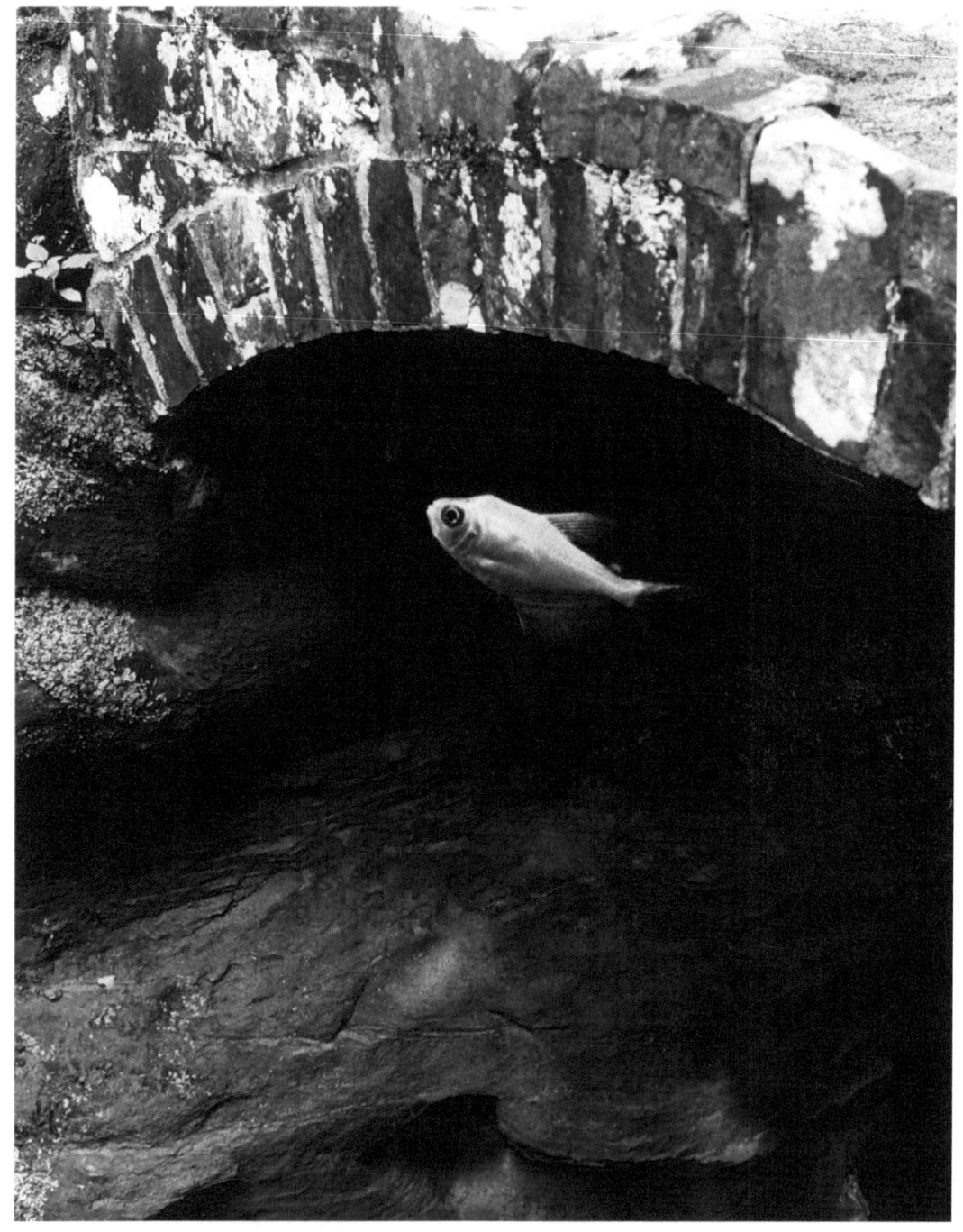

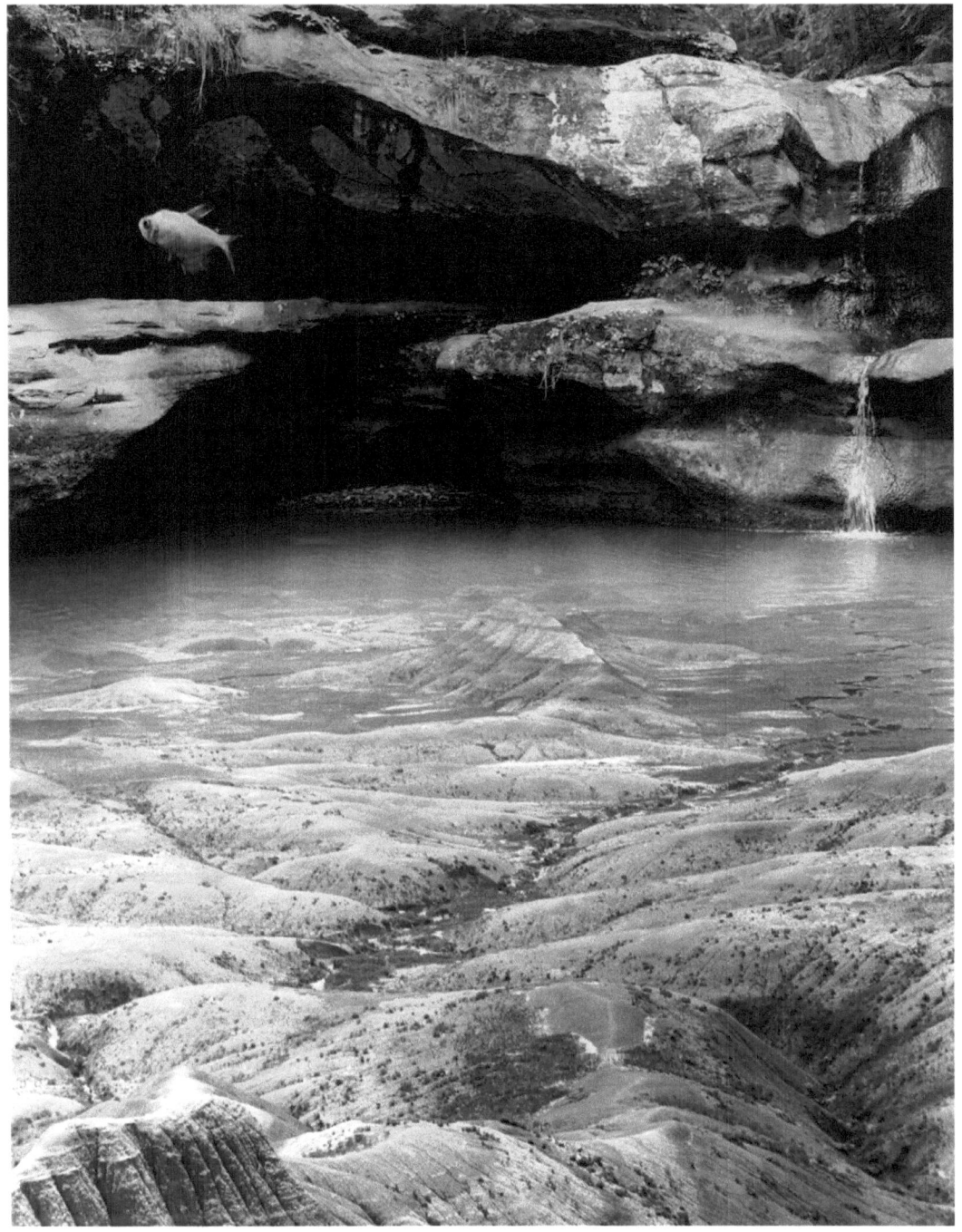

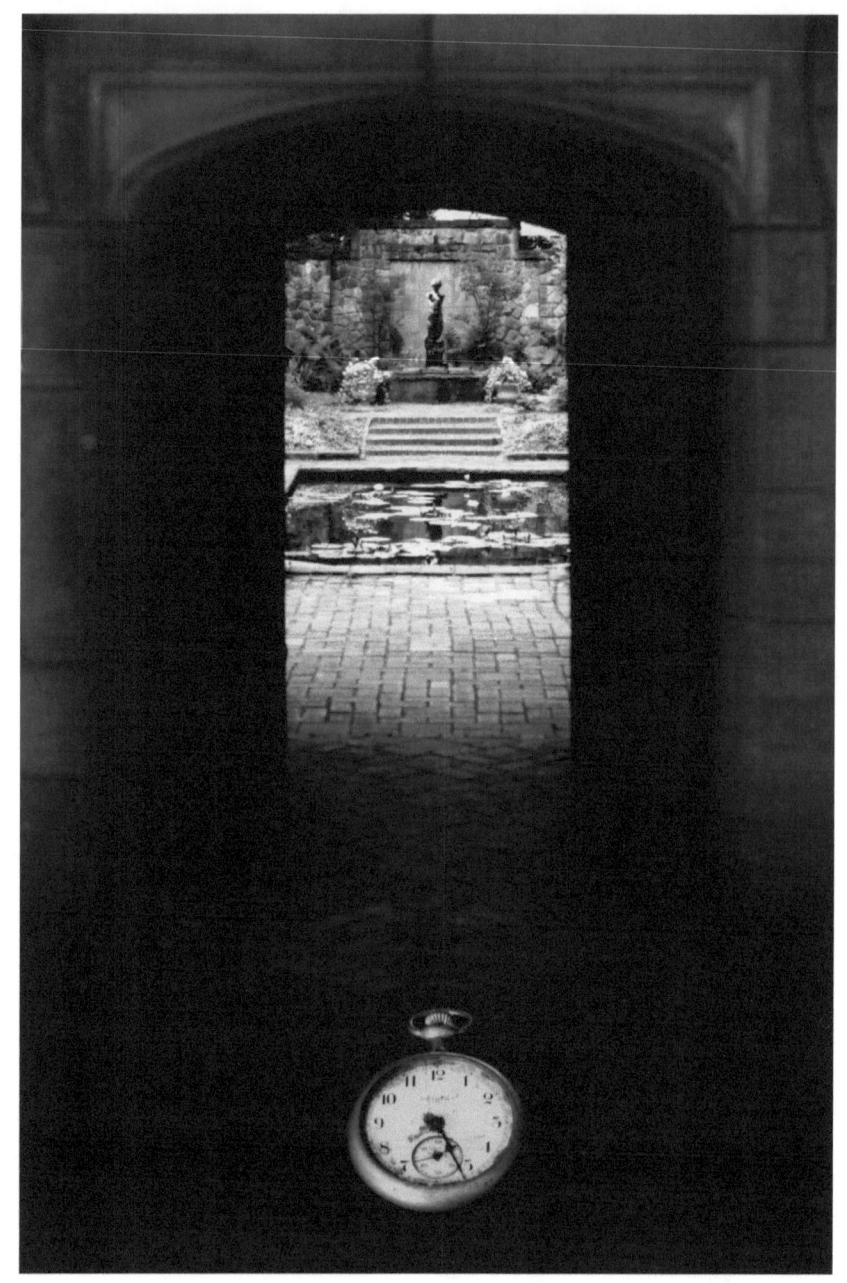

Timeless

Timeless

 I'm ambling down the trail in the snow with my dogs, Lady and Penny, on either end of a long leash and I'm totally in my head about this book. What images should I choose and why? Do I have anything to say about them, or should I just let the images talk? Is the book an ego thing, or do I really think anyone will care?

While I'm in dreamland, Lady and Penny suddenly catch the scent of something and scoot past, wrapping the leash around me and dragging me to the base of a nearby tree. Lady has her head deep in the fresh snow, snuffling all around. Penny is practically right on top of her with an excited growl in her throat. It is an old pine tree. I can smell it. There are some Chickadees up there discussing us. Big fluffy flakes of snow are coming down and I am here. I am awake.

There is no such thing as time. There is only now. This is all you get. The past and the future are convenient and useful notions that help us get along in the world, but it's all too easy to get lost in them. Let's wake up. This, right now, is all we really have to work with. That's the way it is.

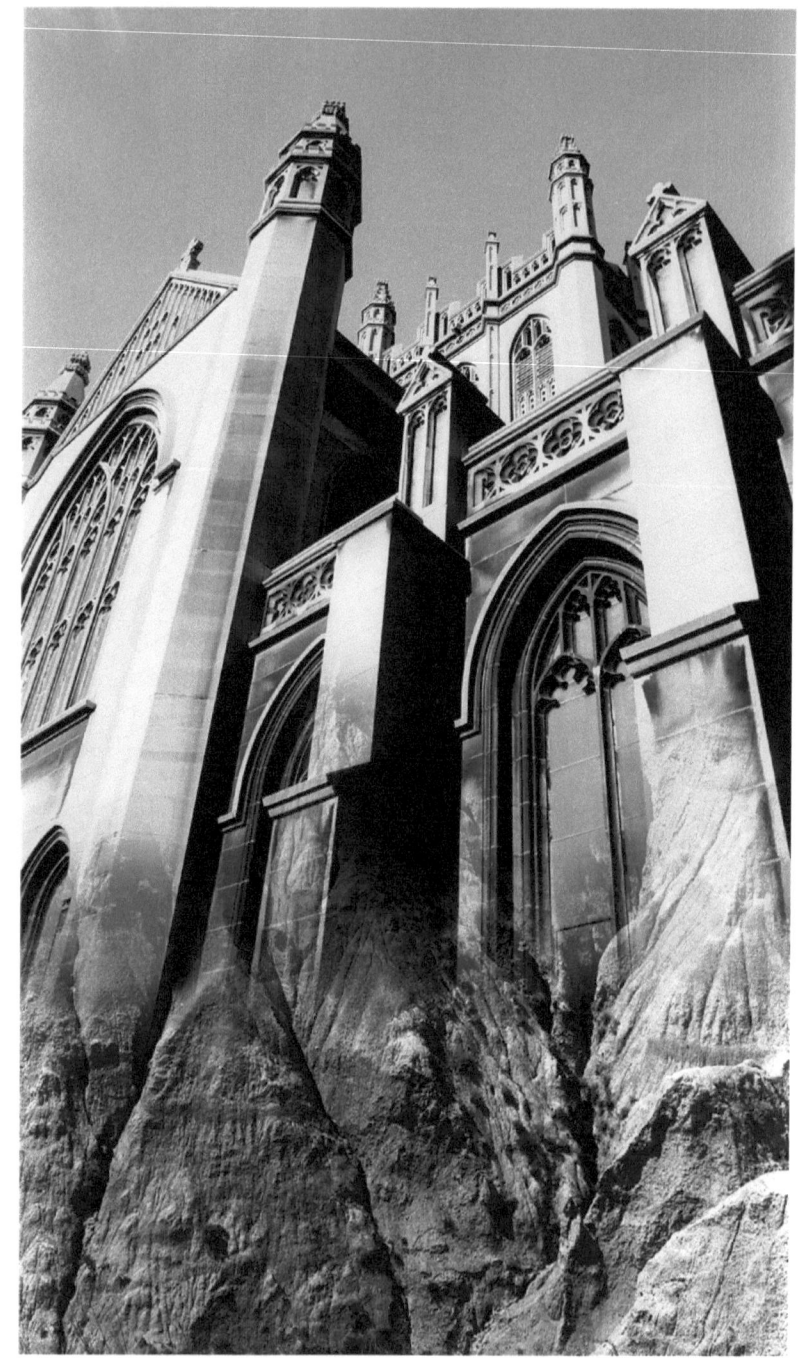

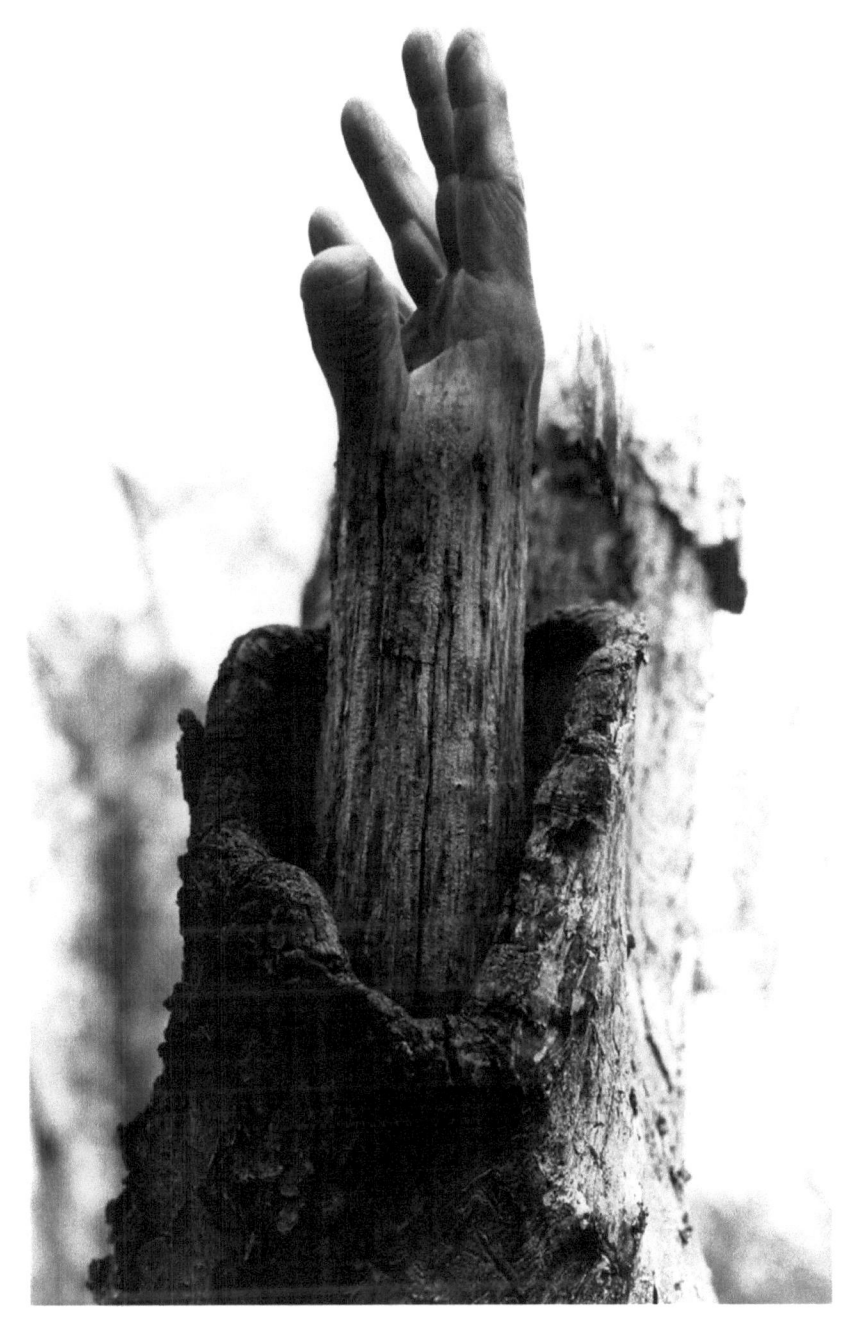

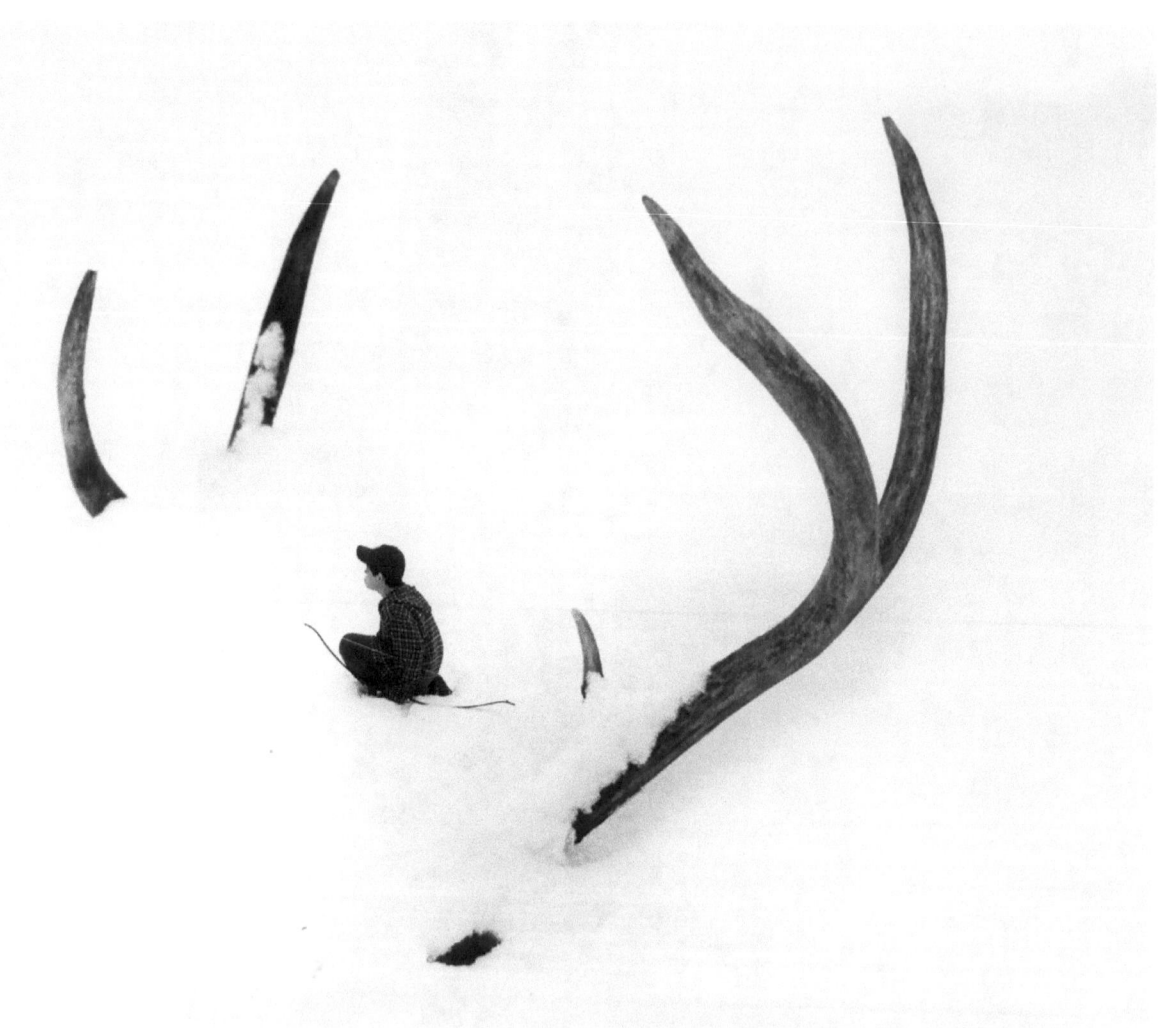

Deer Hunter

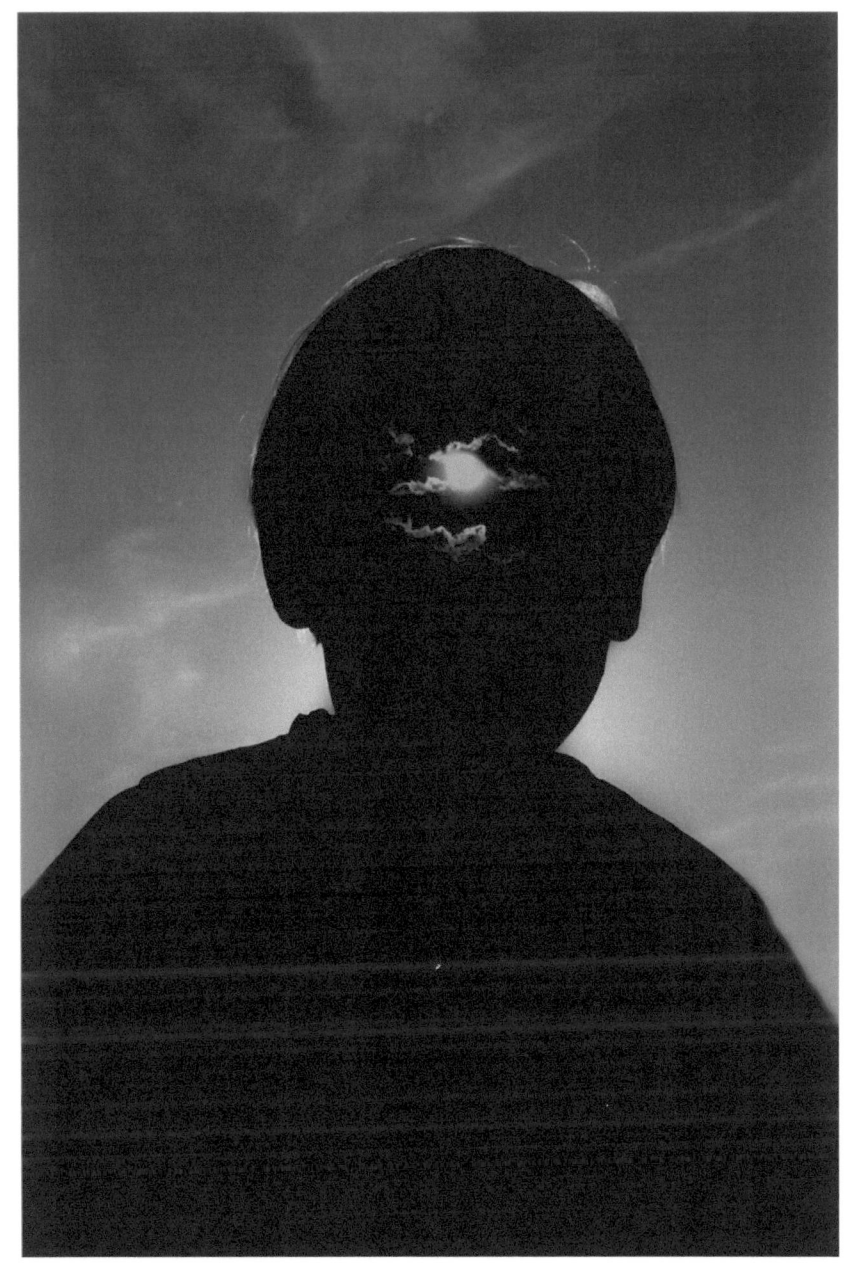

Son Moon

Hands

Using our hands is supposed to be why our species developed the big brain. I'm pretty sure you don't even need opposable thumbs for digital printing. What does that mean for future evolution?

Darkroom printing with film is a hands-on craft. Ninety percent of what I know about darkroom work came quickly and easily, mostly from reading. My hands learned the rest over a period of several years. Sometimes I watch my hands when they are performing a tricky maneuver. I'm not fully conscious of what exactly they know, but I marvel at them when they do their thing.

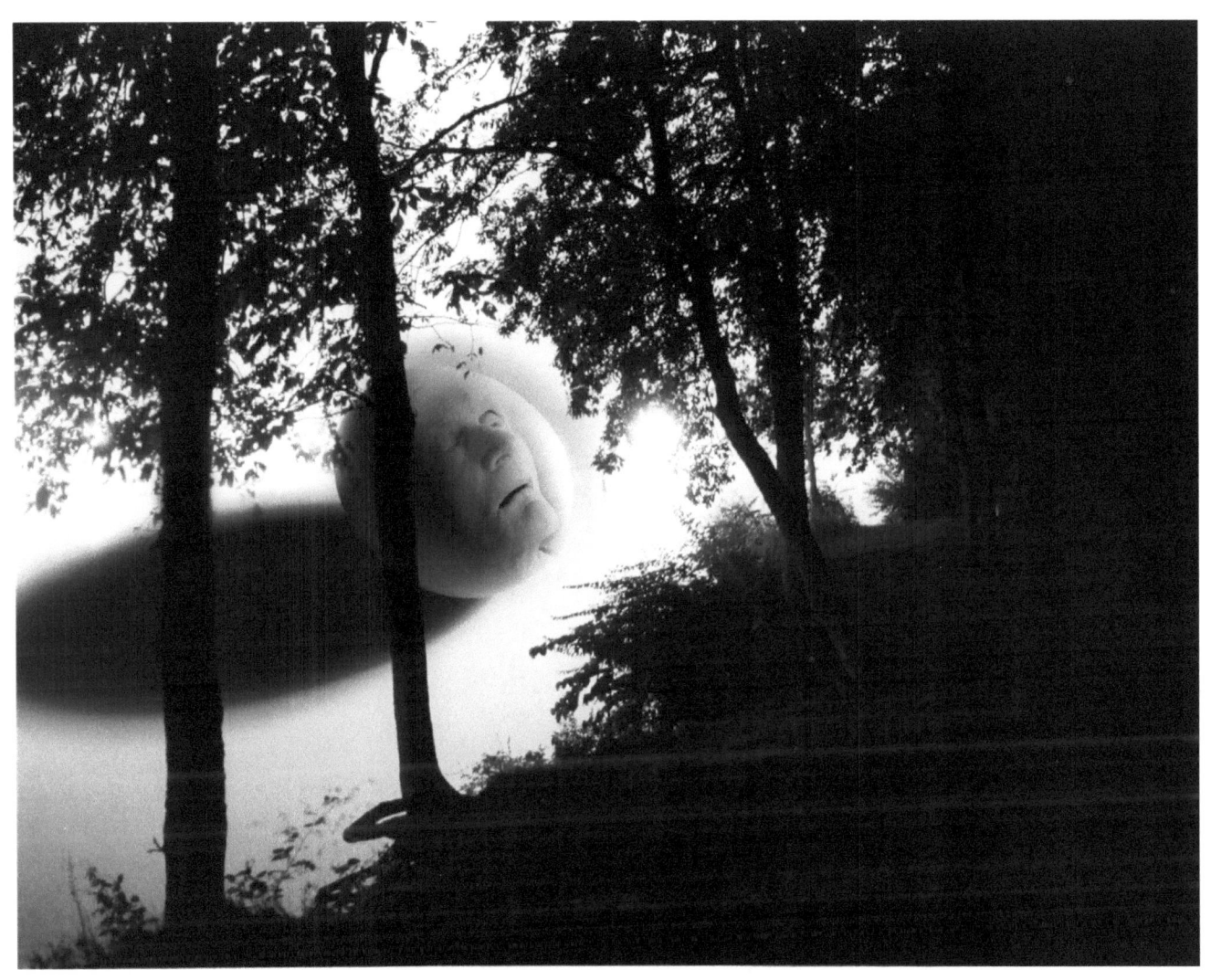

Rebirth

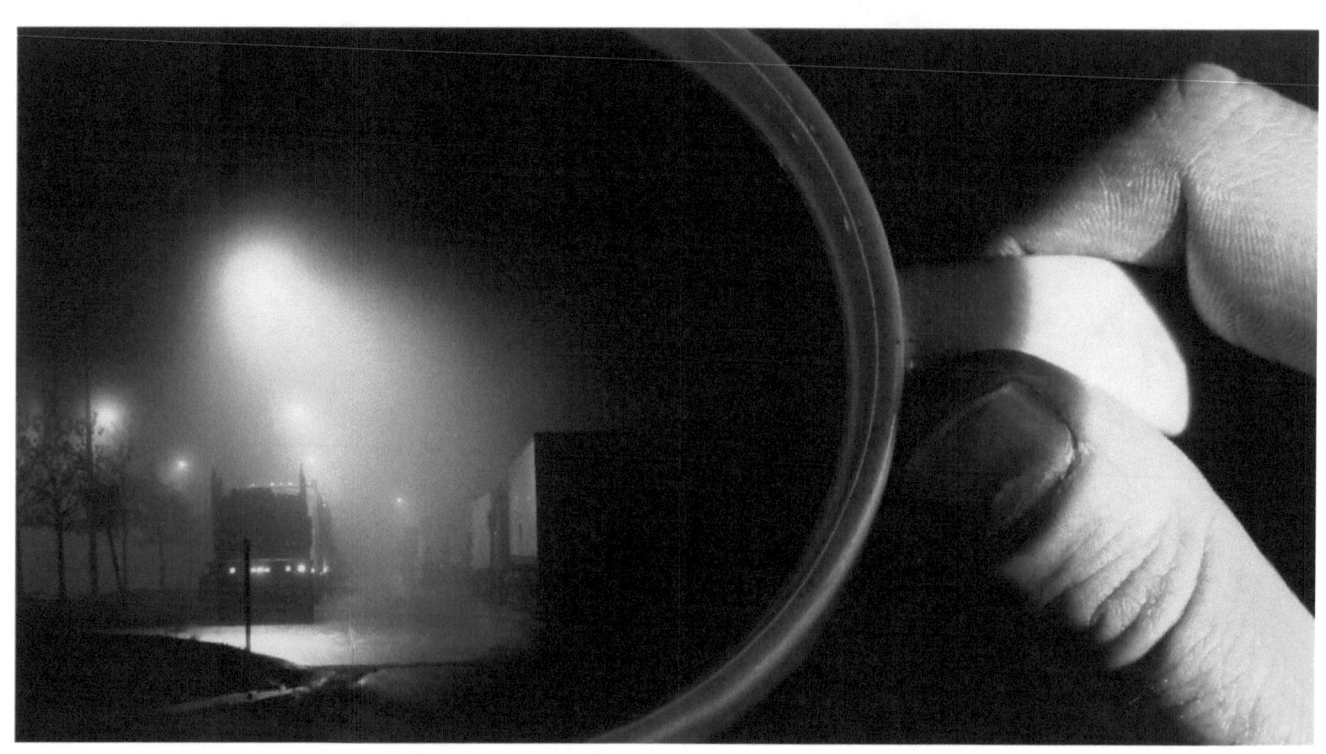

Coffee

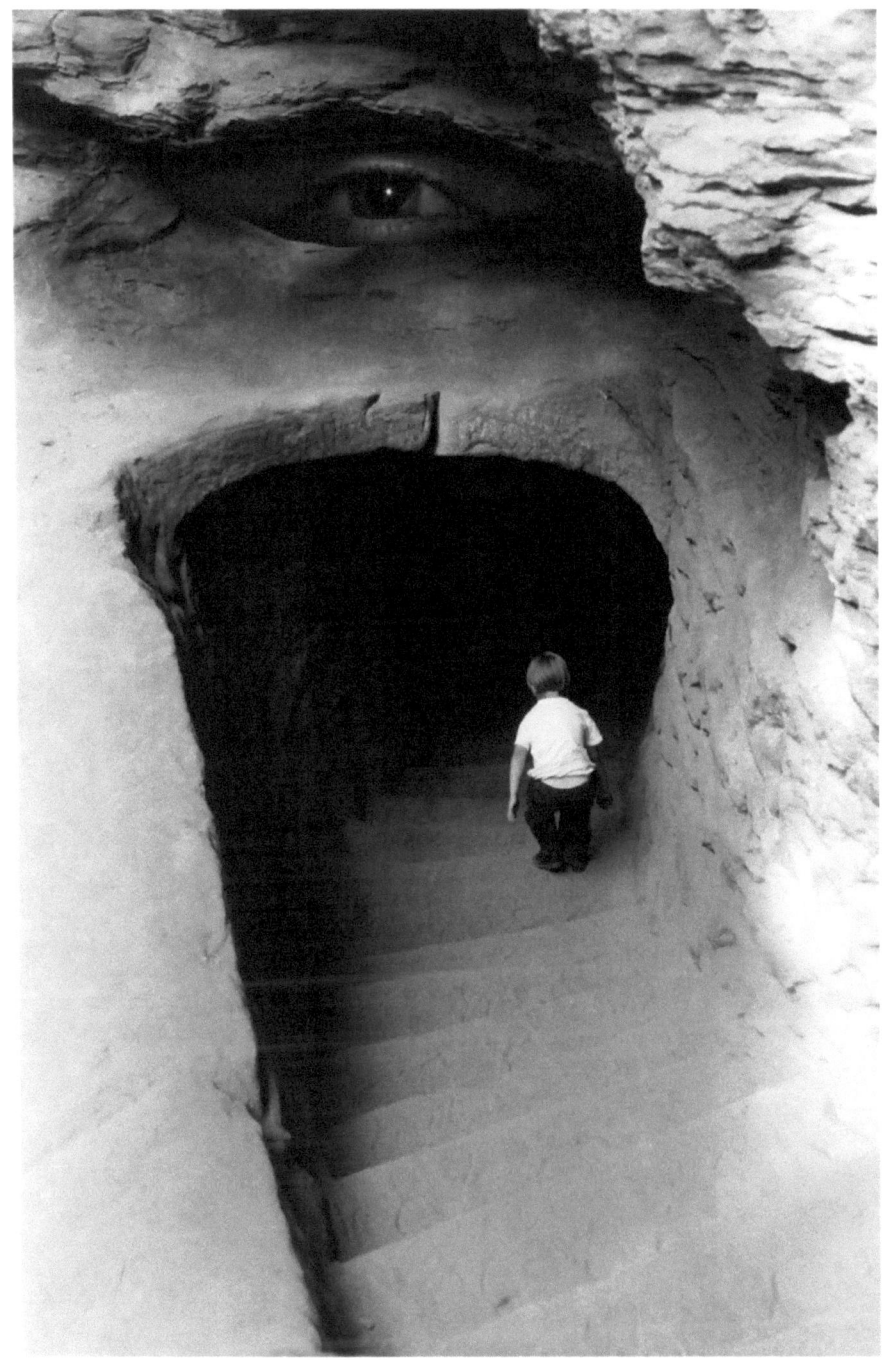

Titles

Everyone sees the world differently. I'm amazed when people tell me what they see in my photographs. The title on a work of art can limit the variety of ways viewers interpret it. That's why most of my images are nameless. What do they say to you?

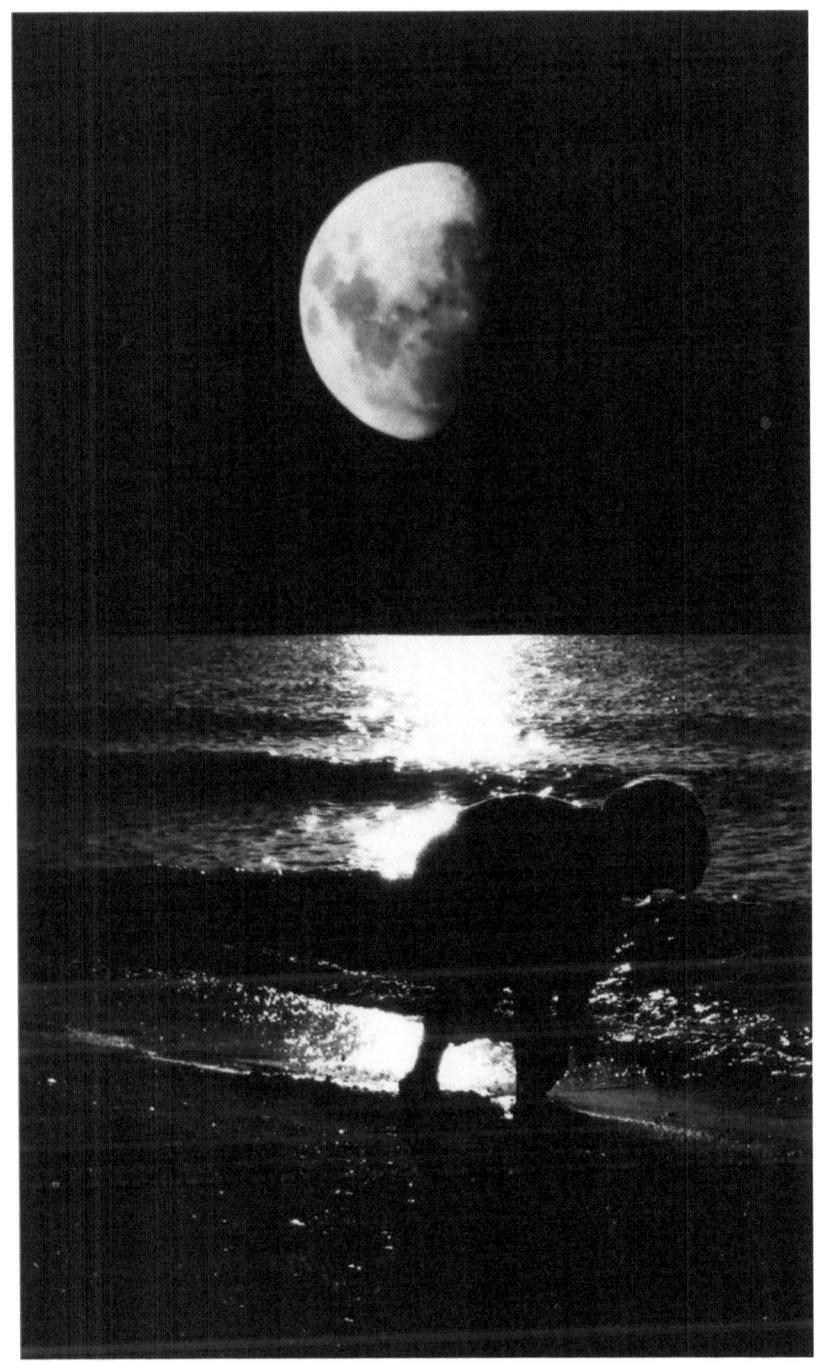

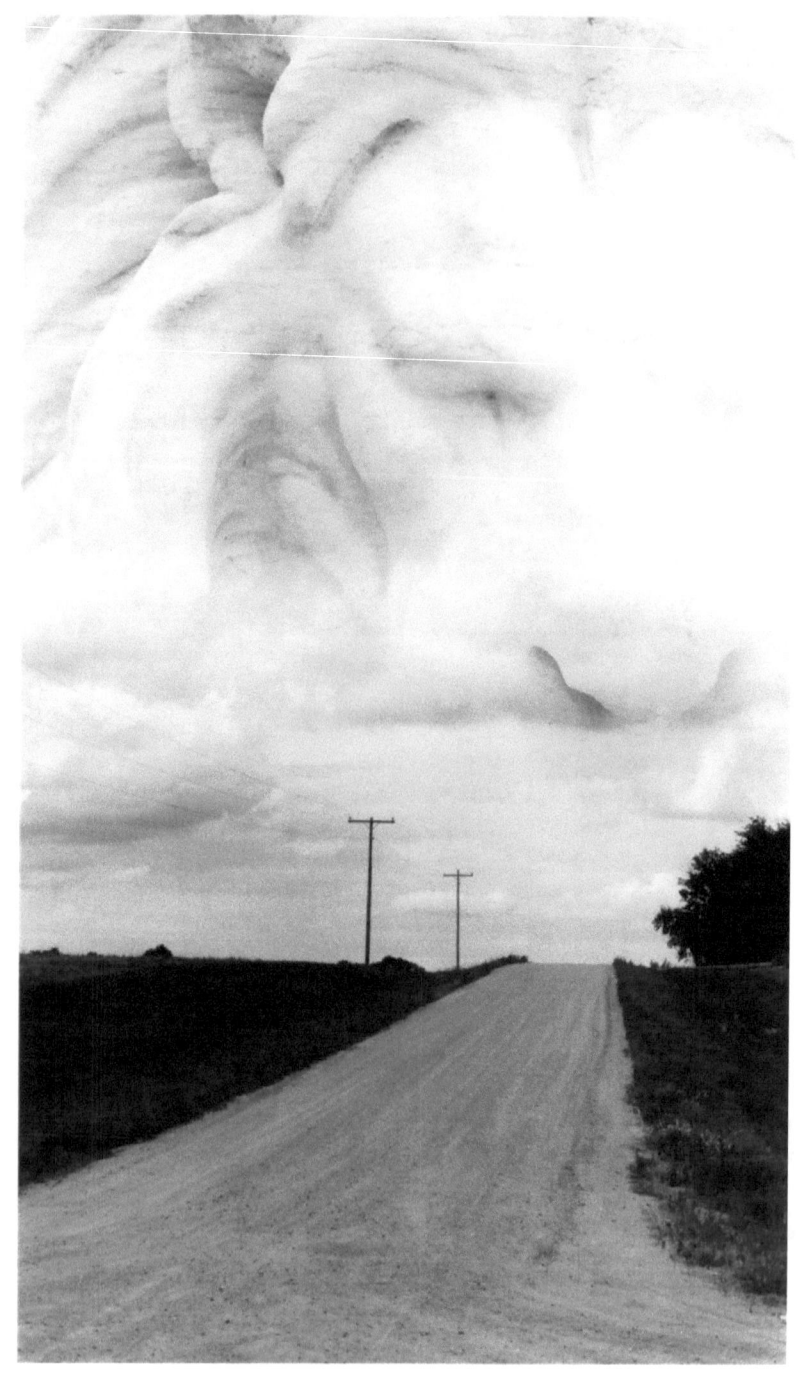

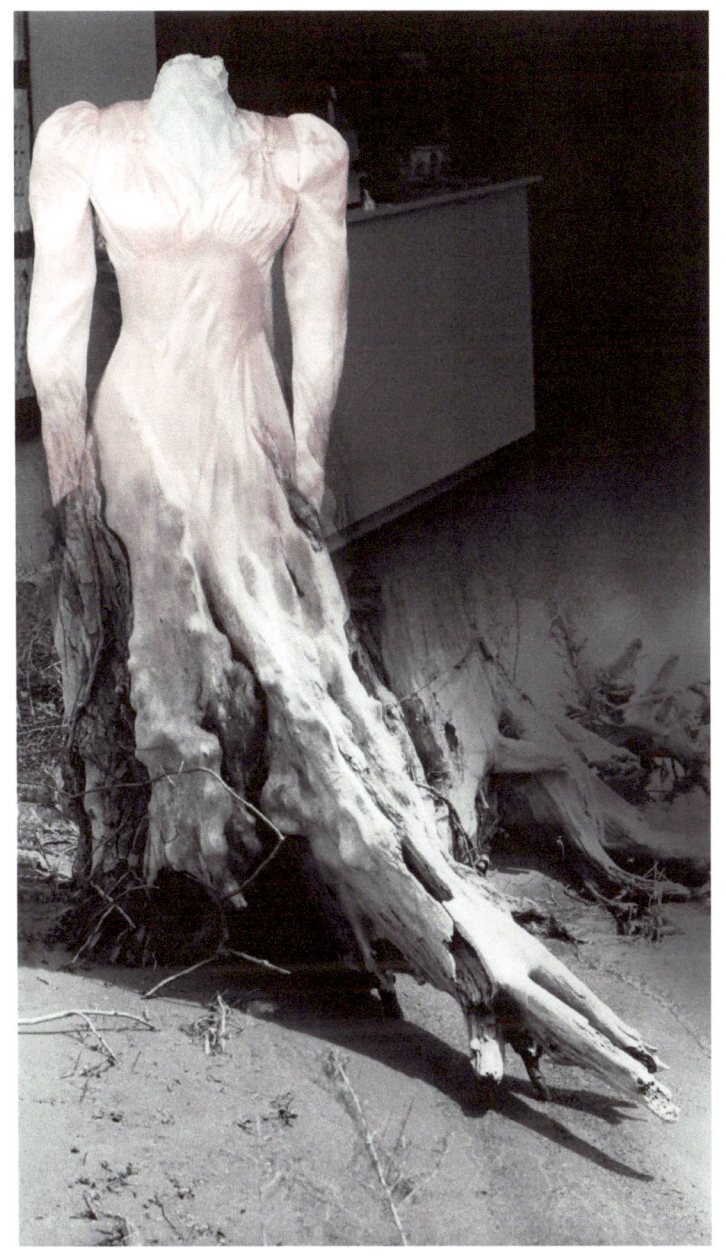

Ms Haversham's Wedding Dress

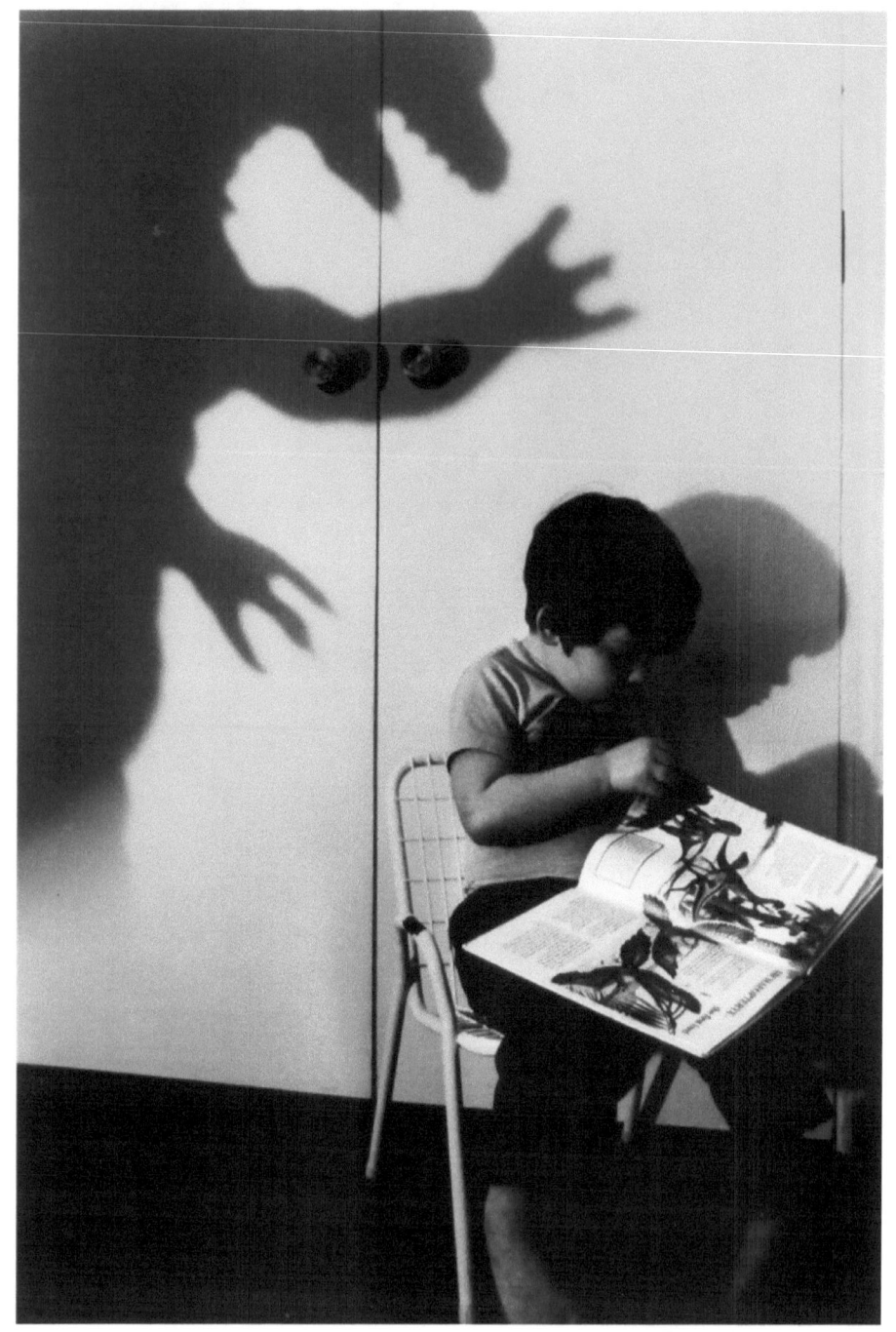

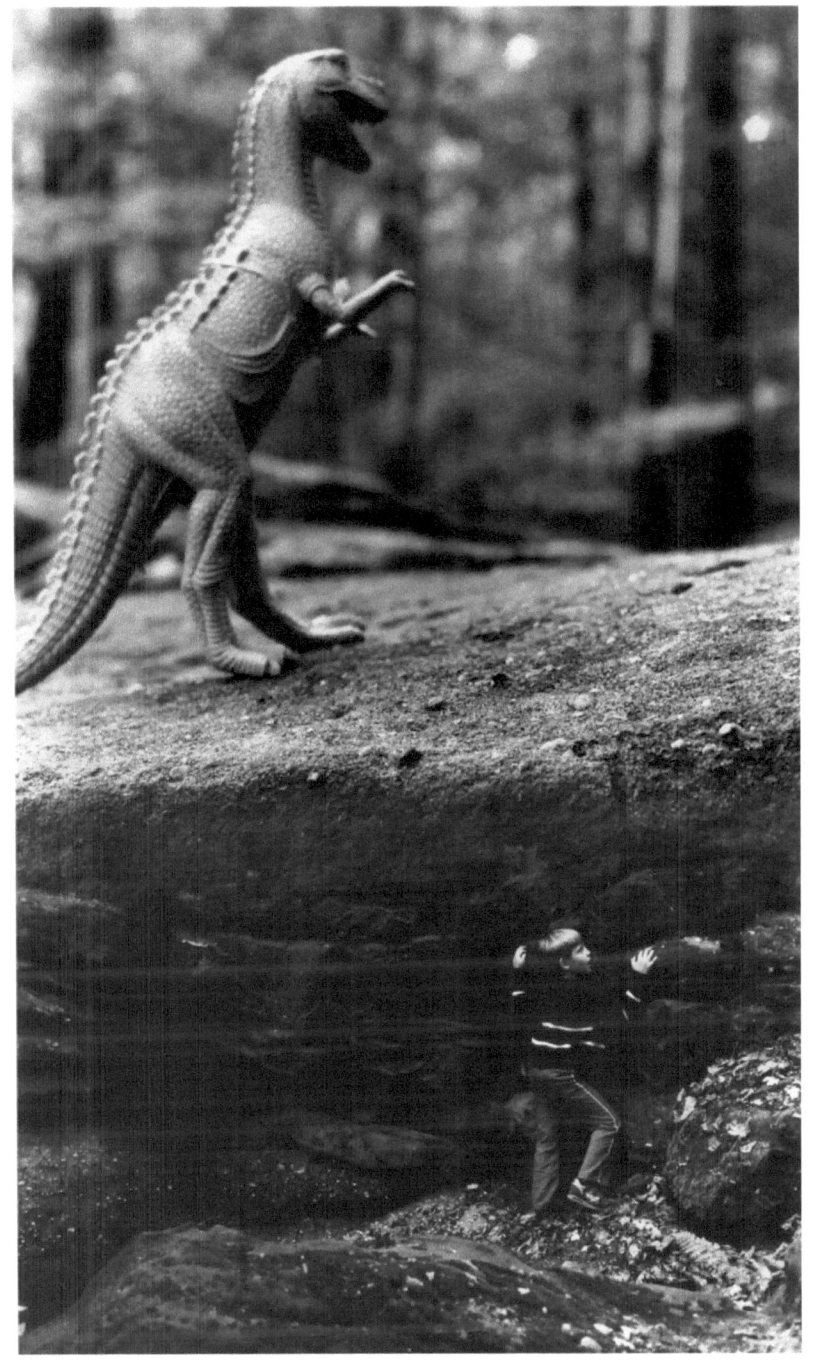

Surfaces

There is so much more to life than appears on the surface. I had visual ideas that ran along those lines, but my first experiments with surfaces were very frustrating. I finally got some limited results with plastic trash can liners stretched on frames, but they were fragile, not very flexible, and too reflective. I put the project out of my mind for ten years, until I happen to find weather balloons for sale in a surplus catalog. I stretched them on large frames and shot a lot of film of people and things pressed against them.

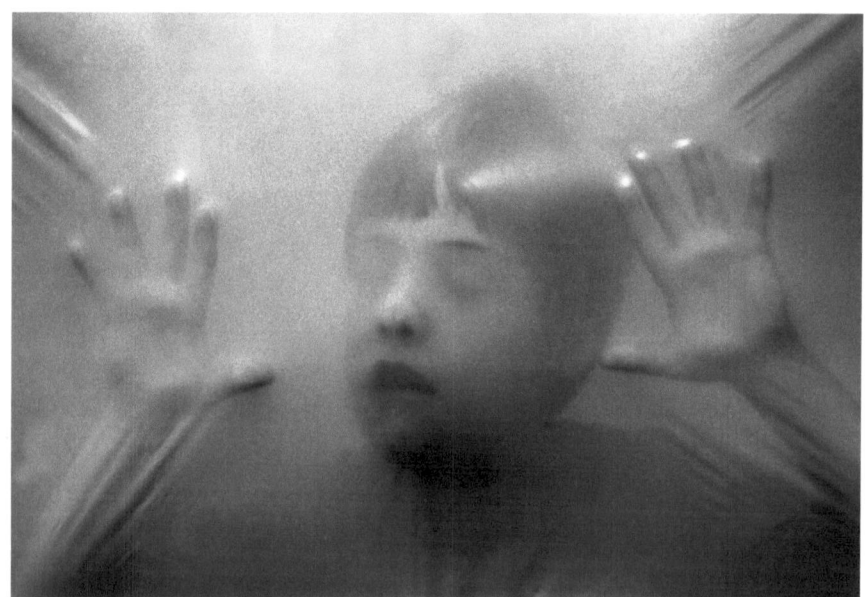

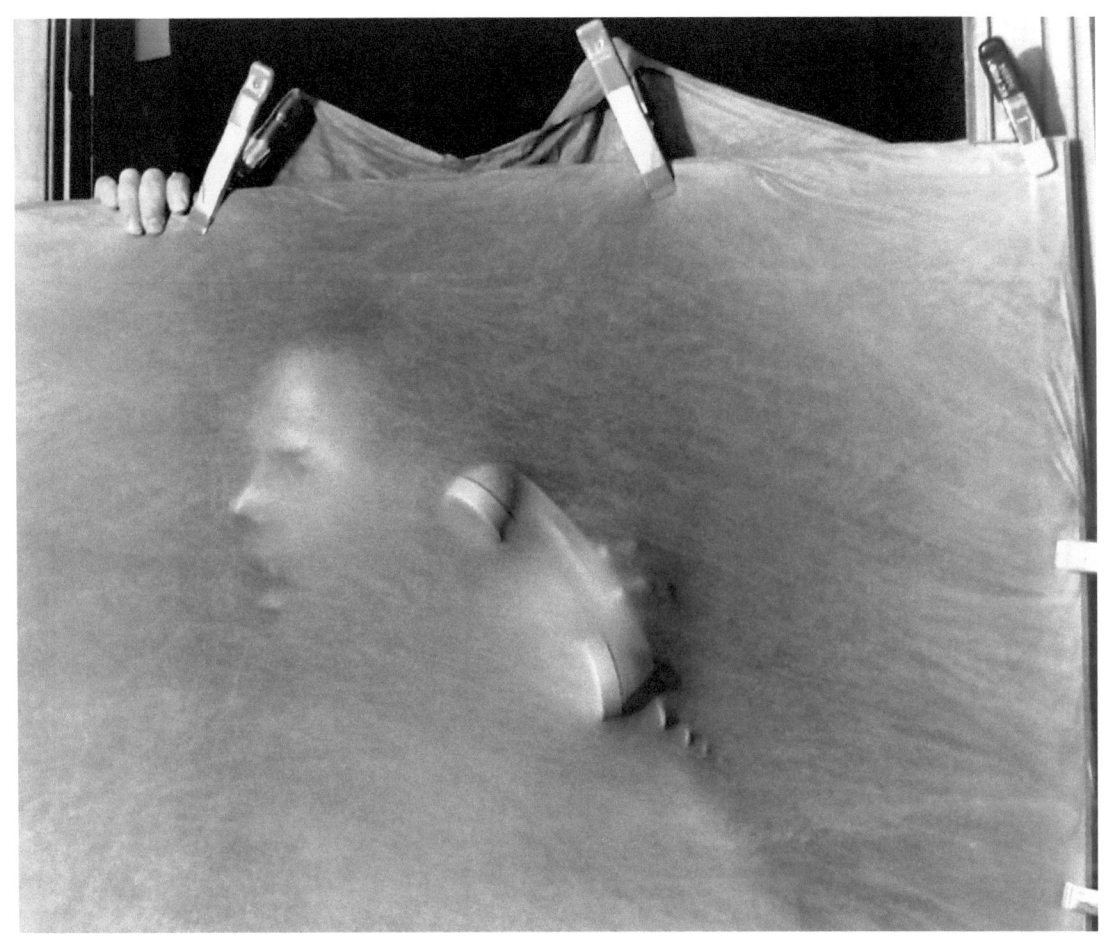

It's For You

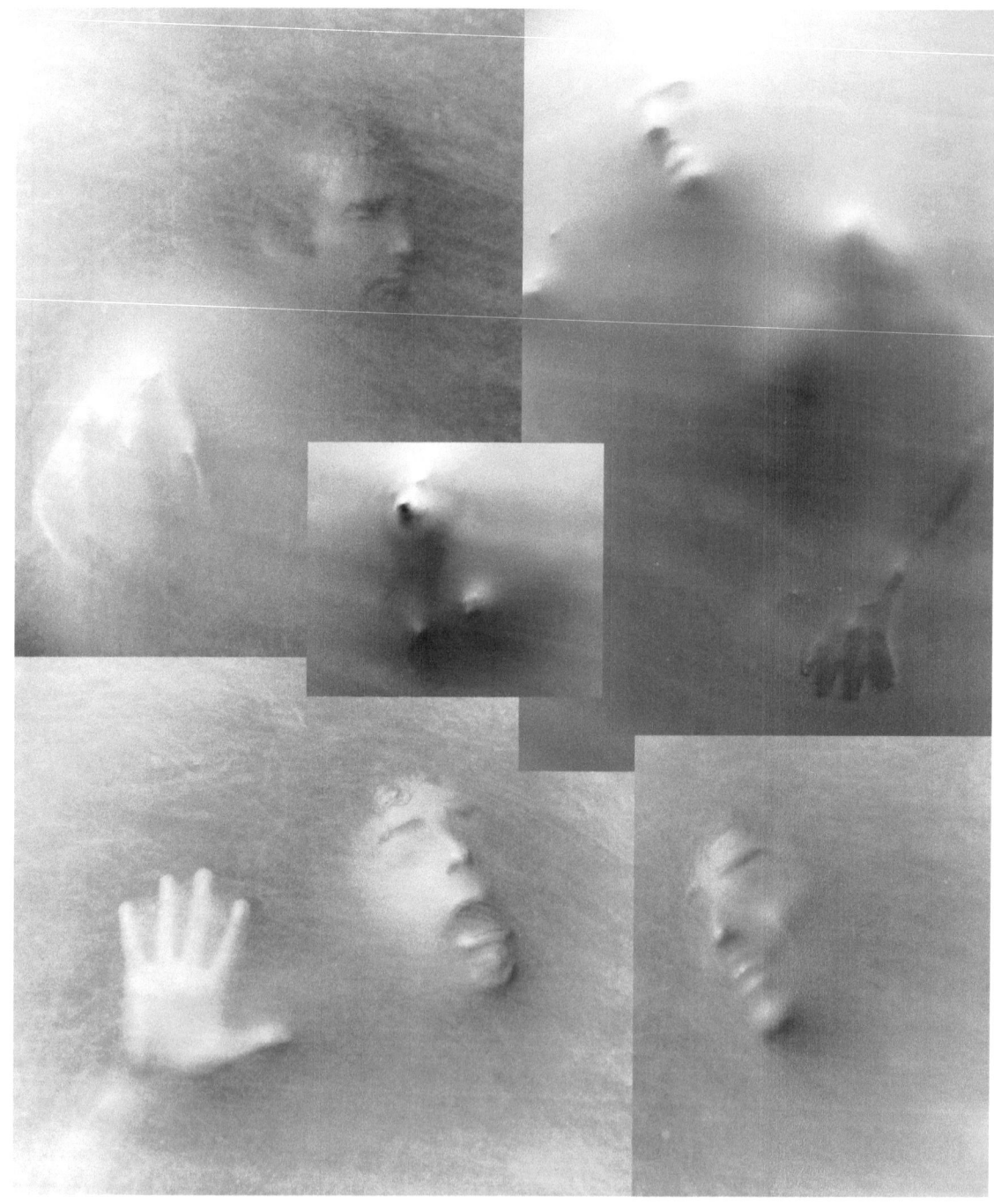

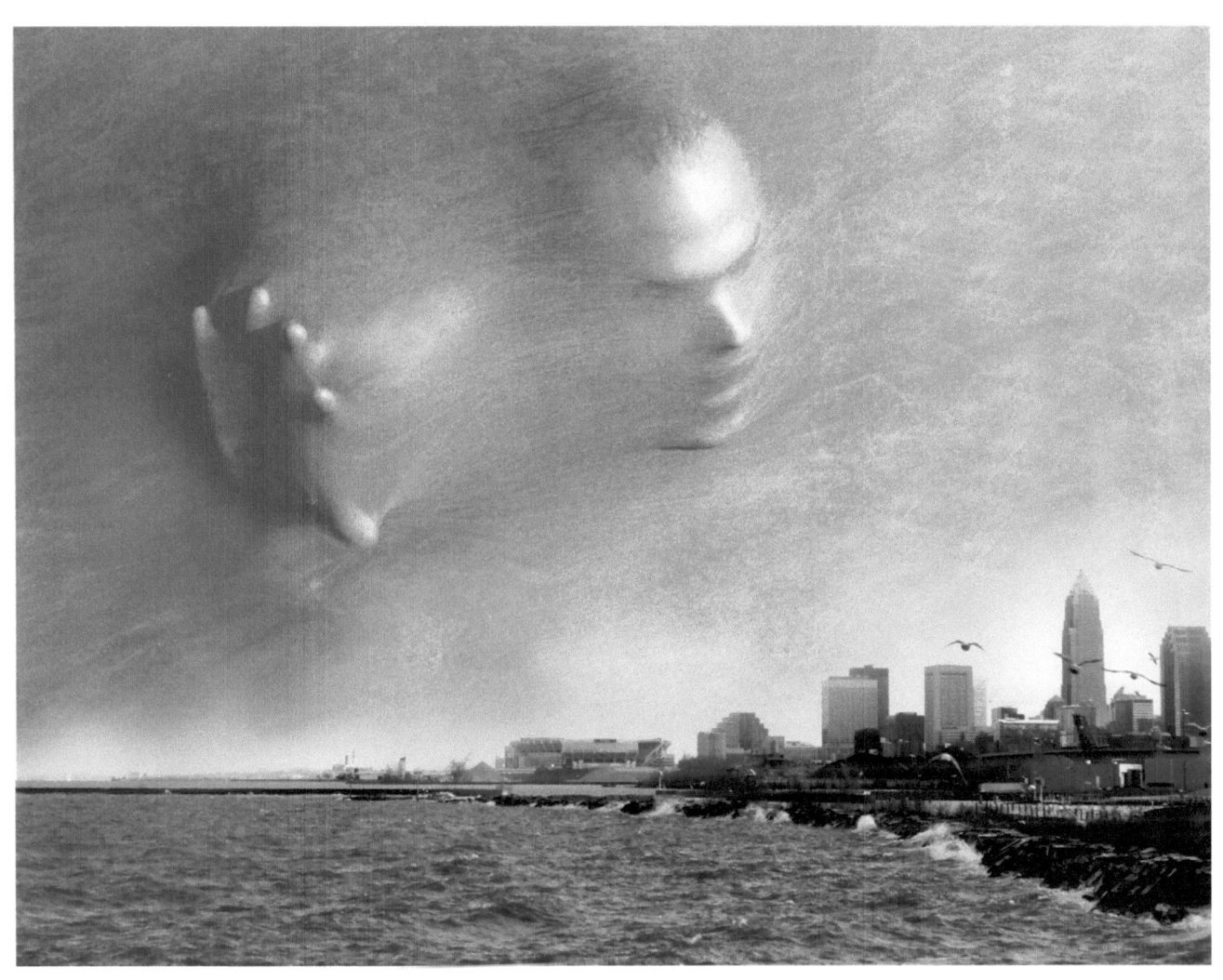

Lake Effect

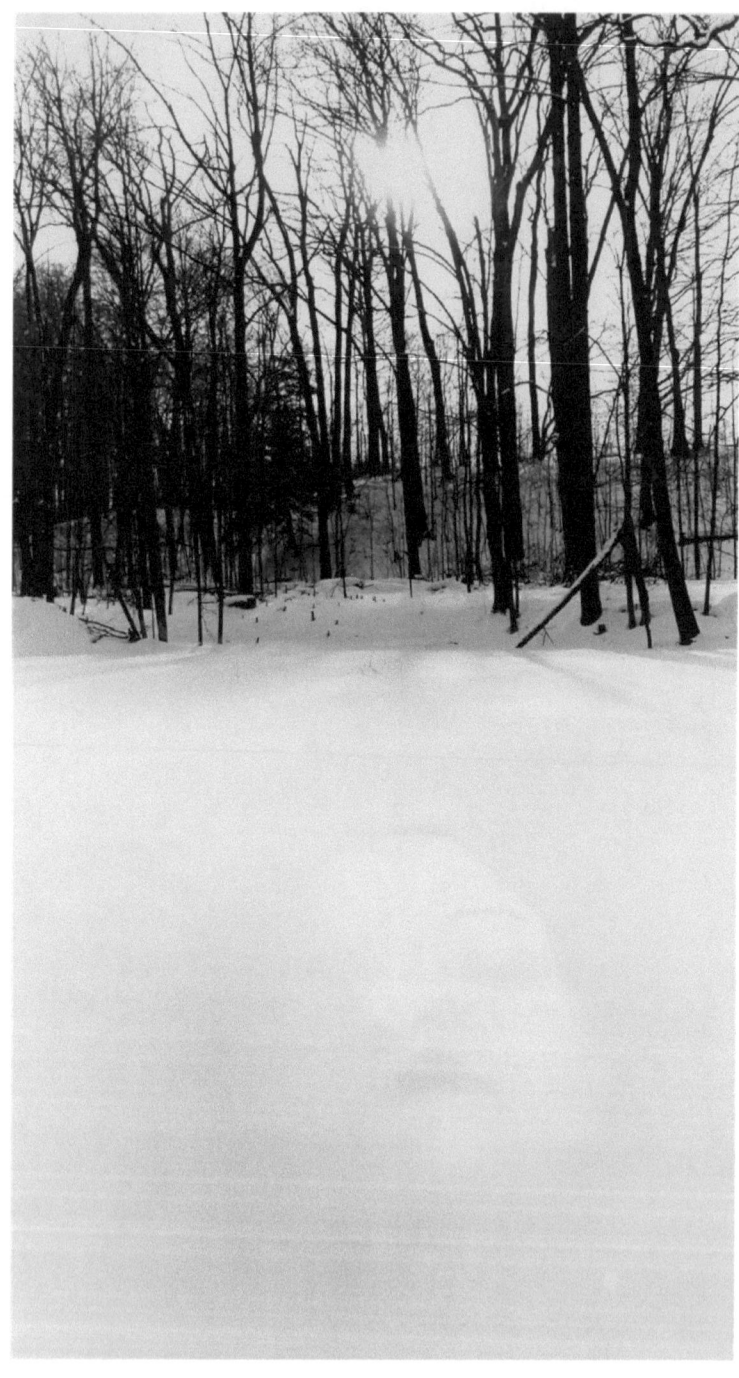

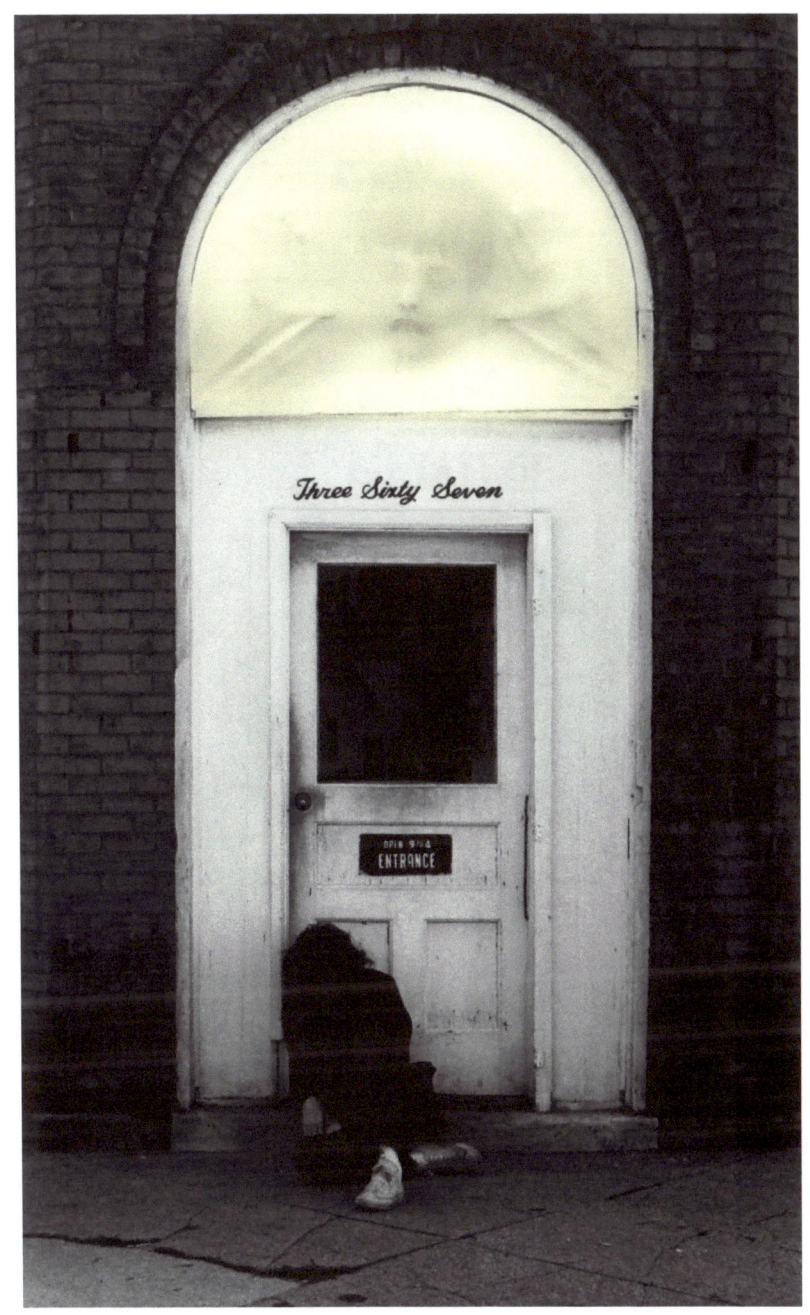

Inner Child

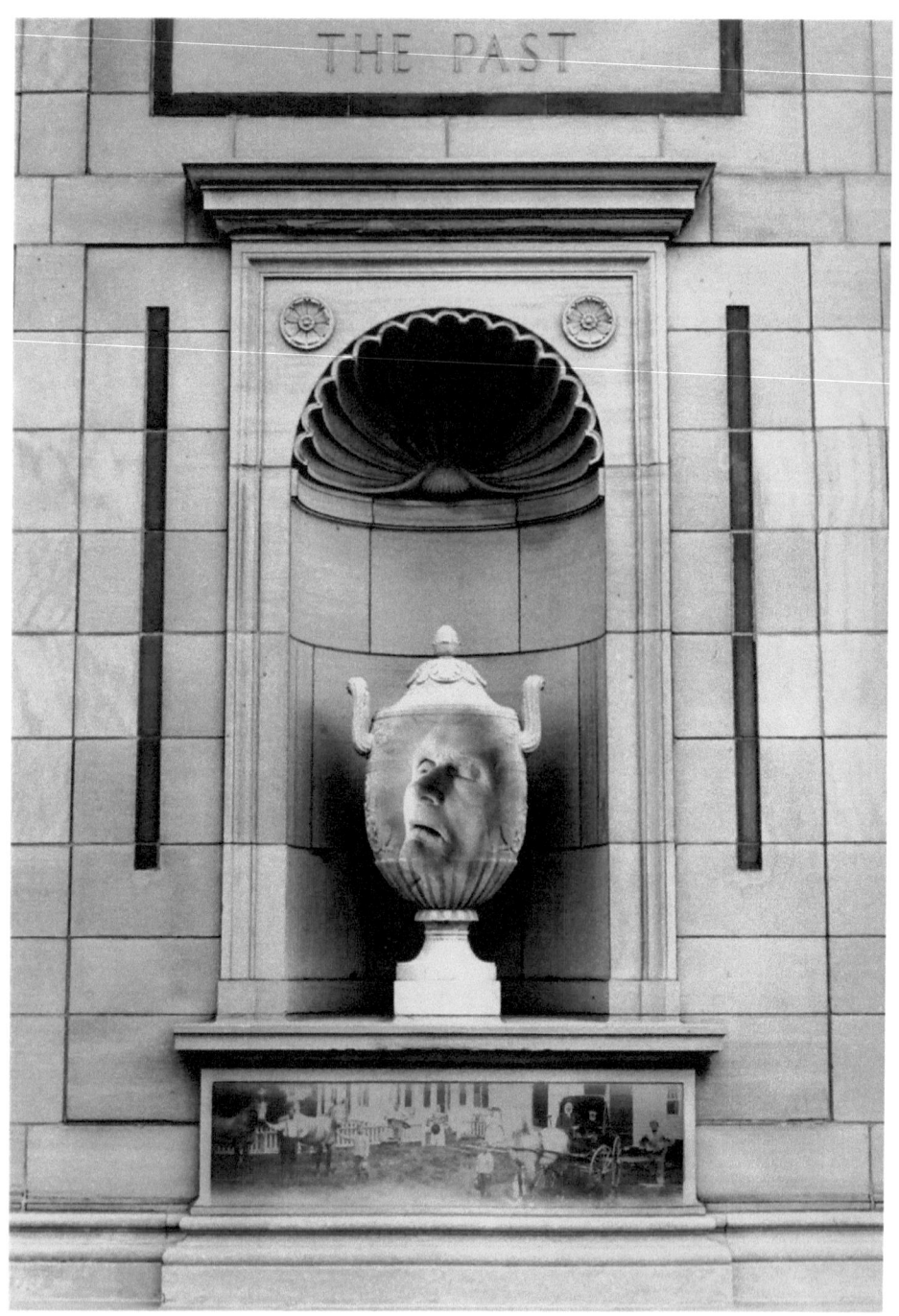

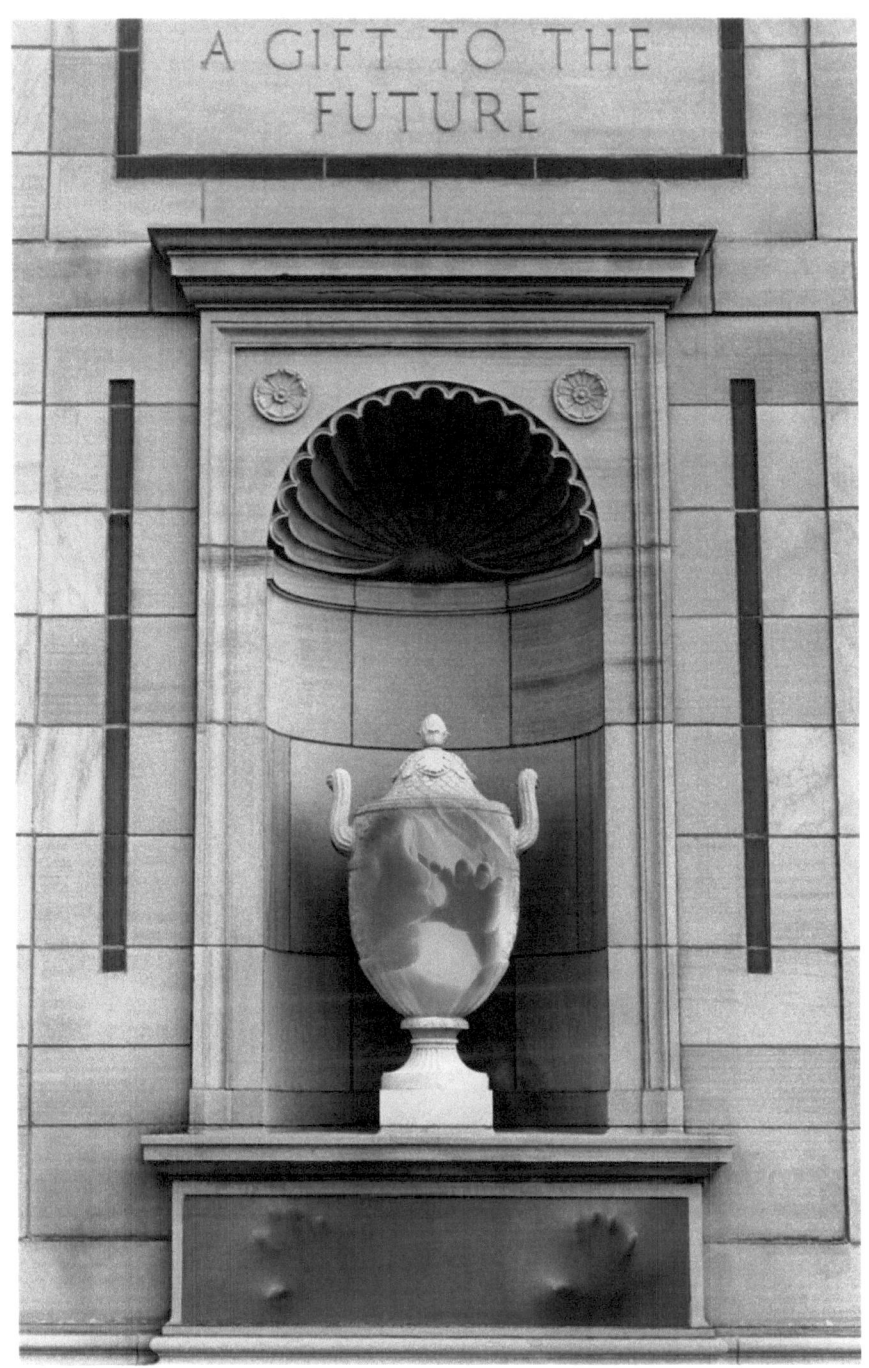

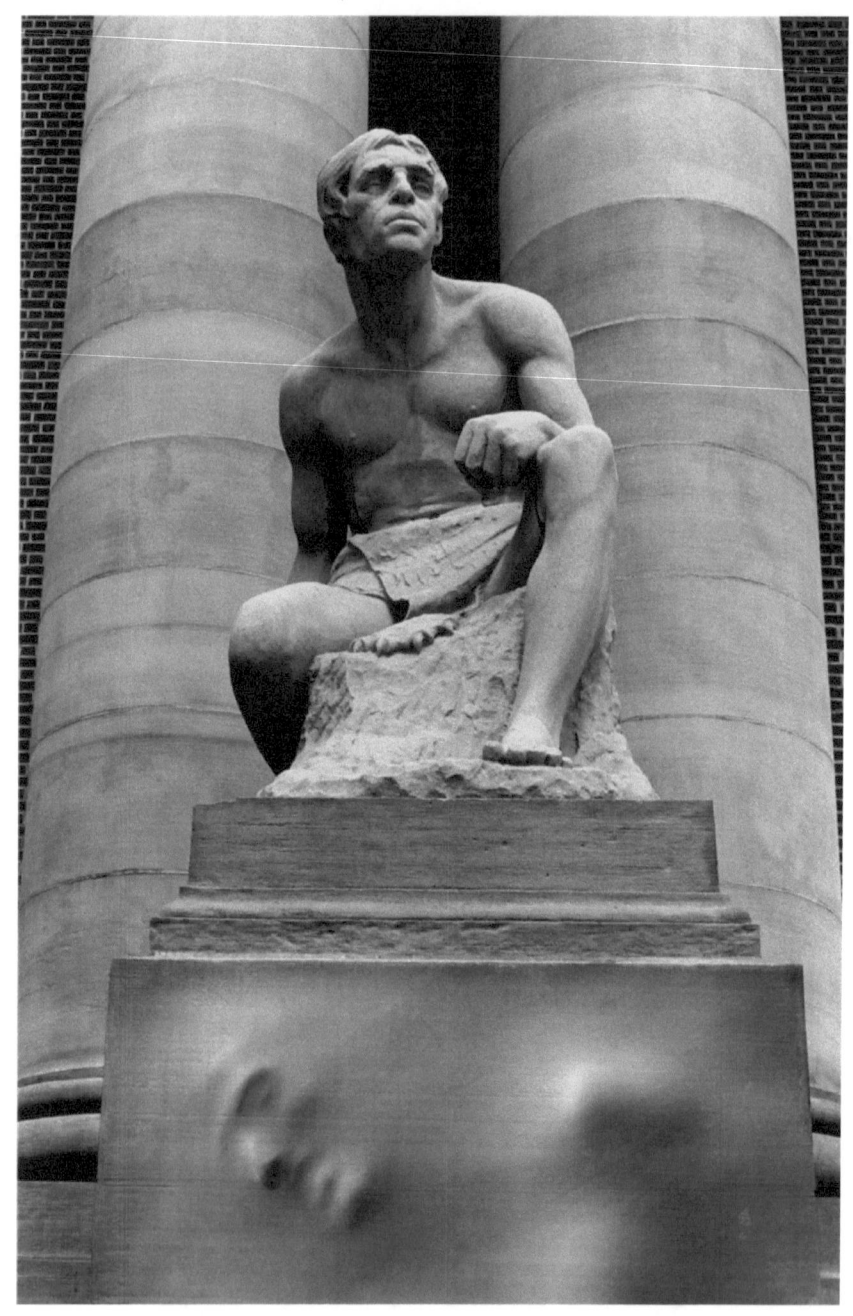

Cain and Abel

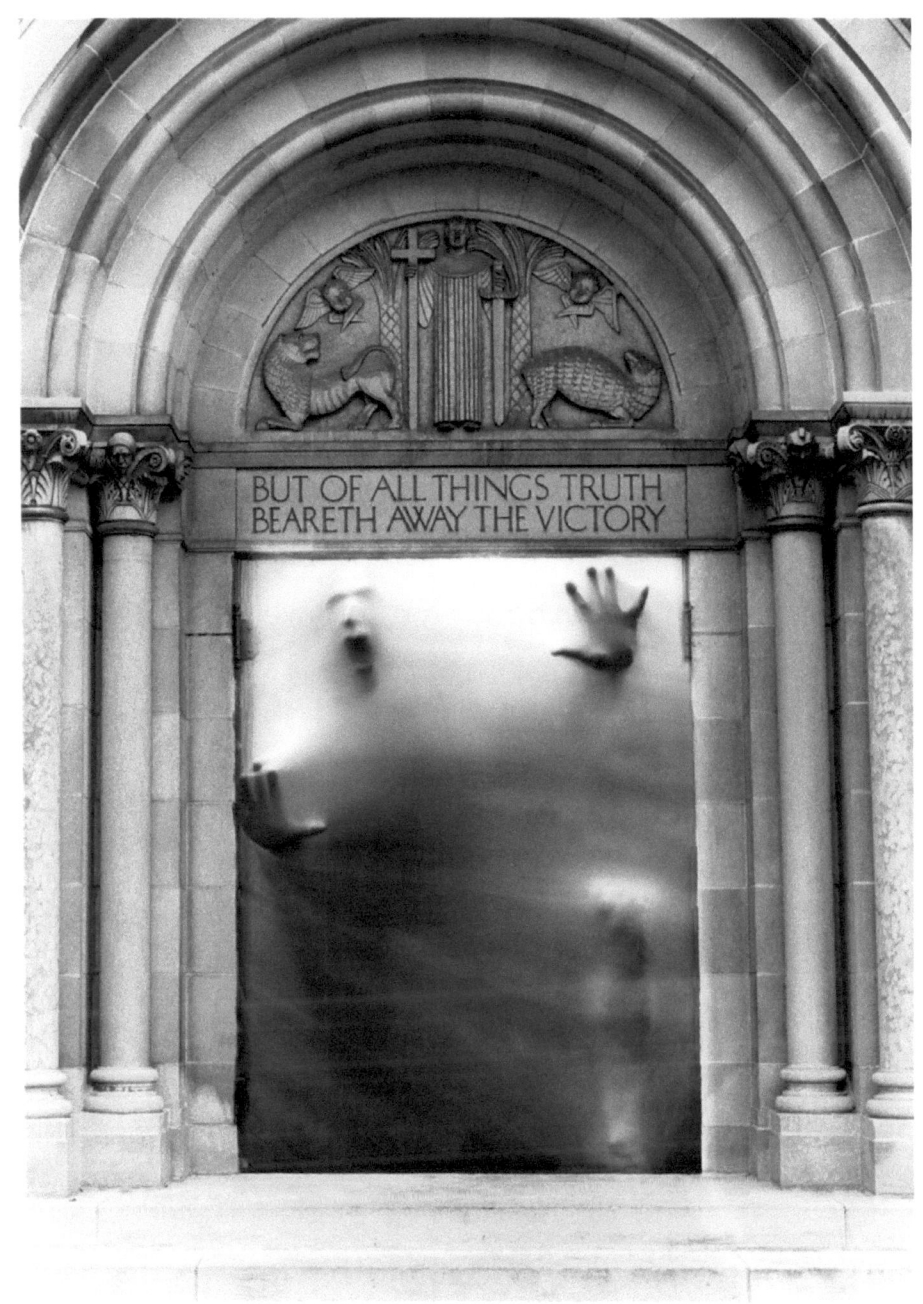

Truth

Split Camera

I found a cheap plastic 35mm camera that was called a split-camera. You could take multiple exposures without advancing the film. Little sliding panels blocked parts of the lens. It was fun, but flimsy and low quality. So I took one of my Canon AE-1s and turned it into a *good* split camera. I carved out half of the lens cap for a blocking device and figured out how to re-cock the shutter. At F8, image blending was seamless. The photographs that followed were spontaneous and required no darkroom trickery. It also allowed me to make simple composites with color film. Great for portraits.

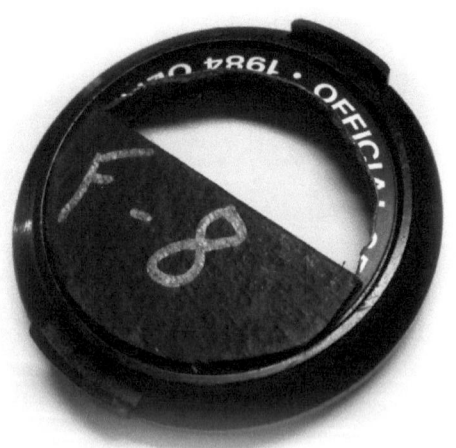

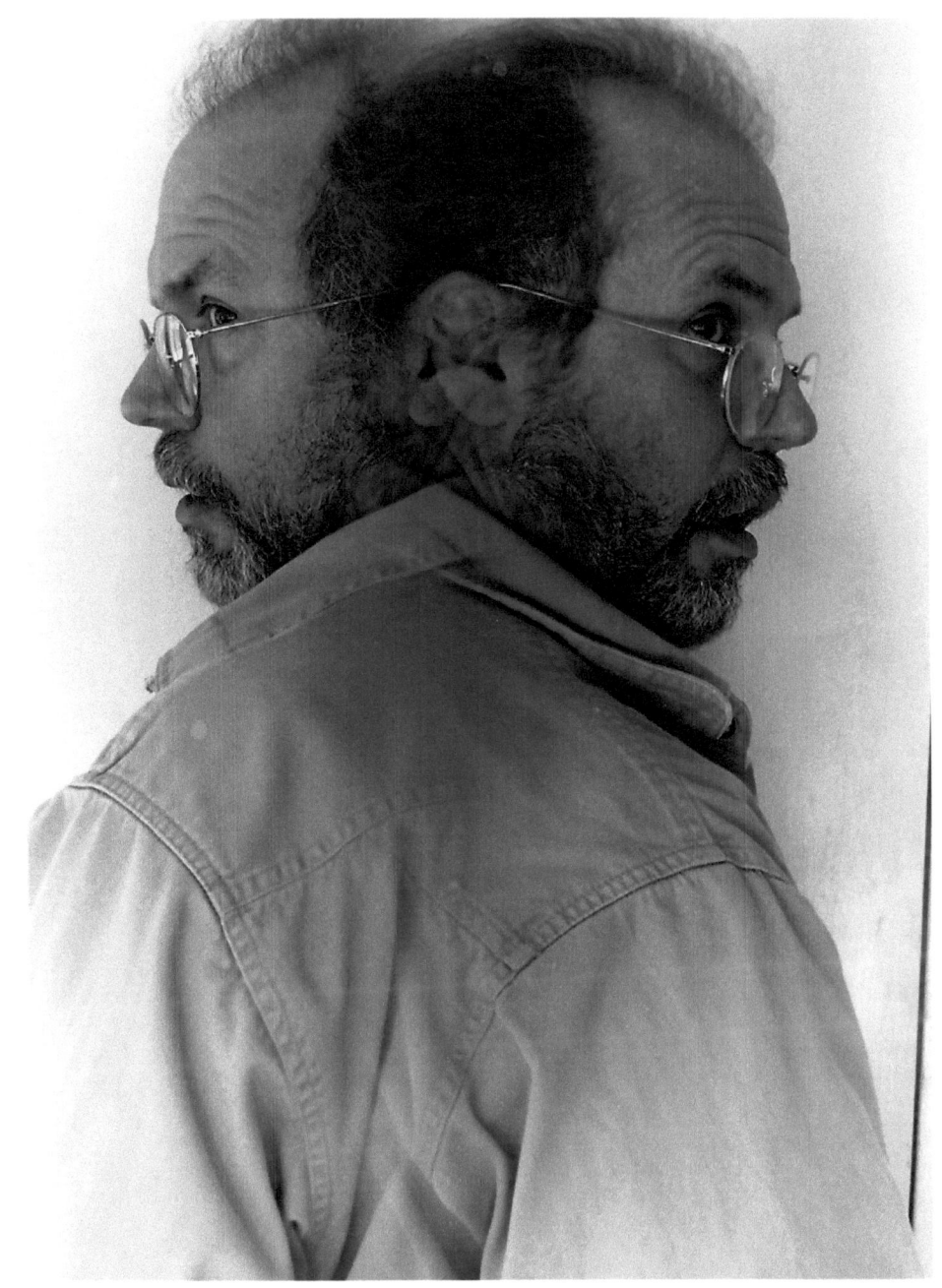

Split camera self portrait

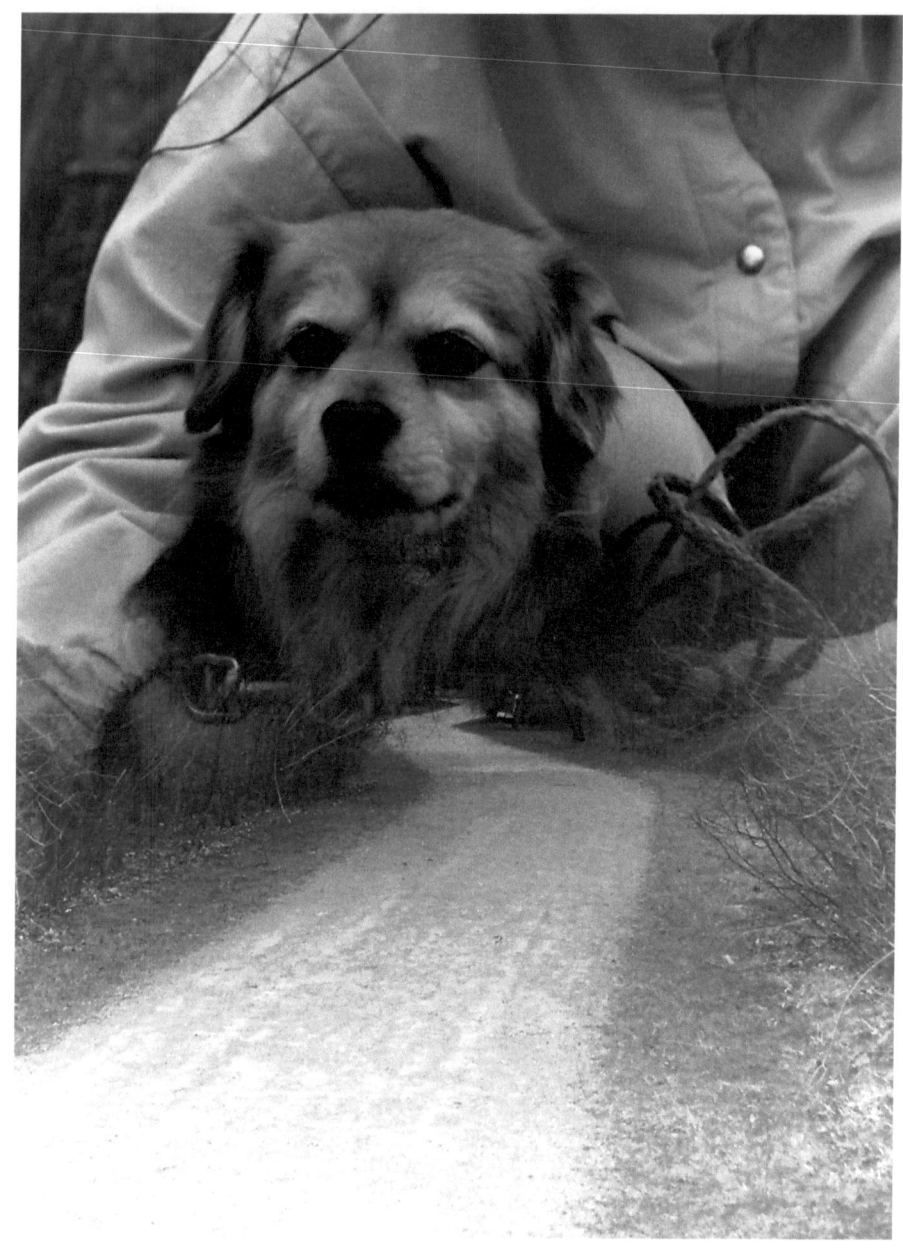

Penny

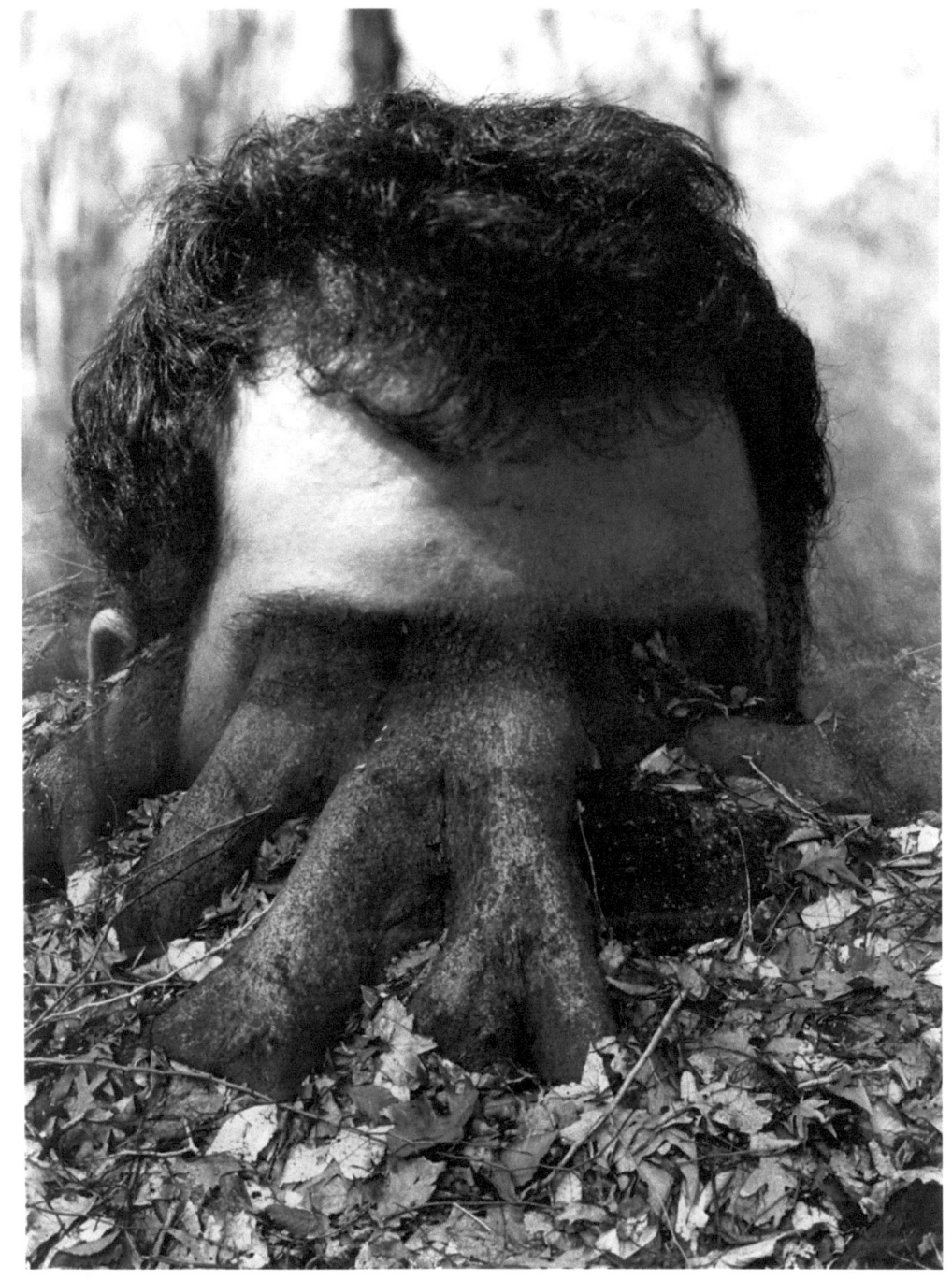

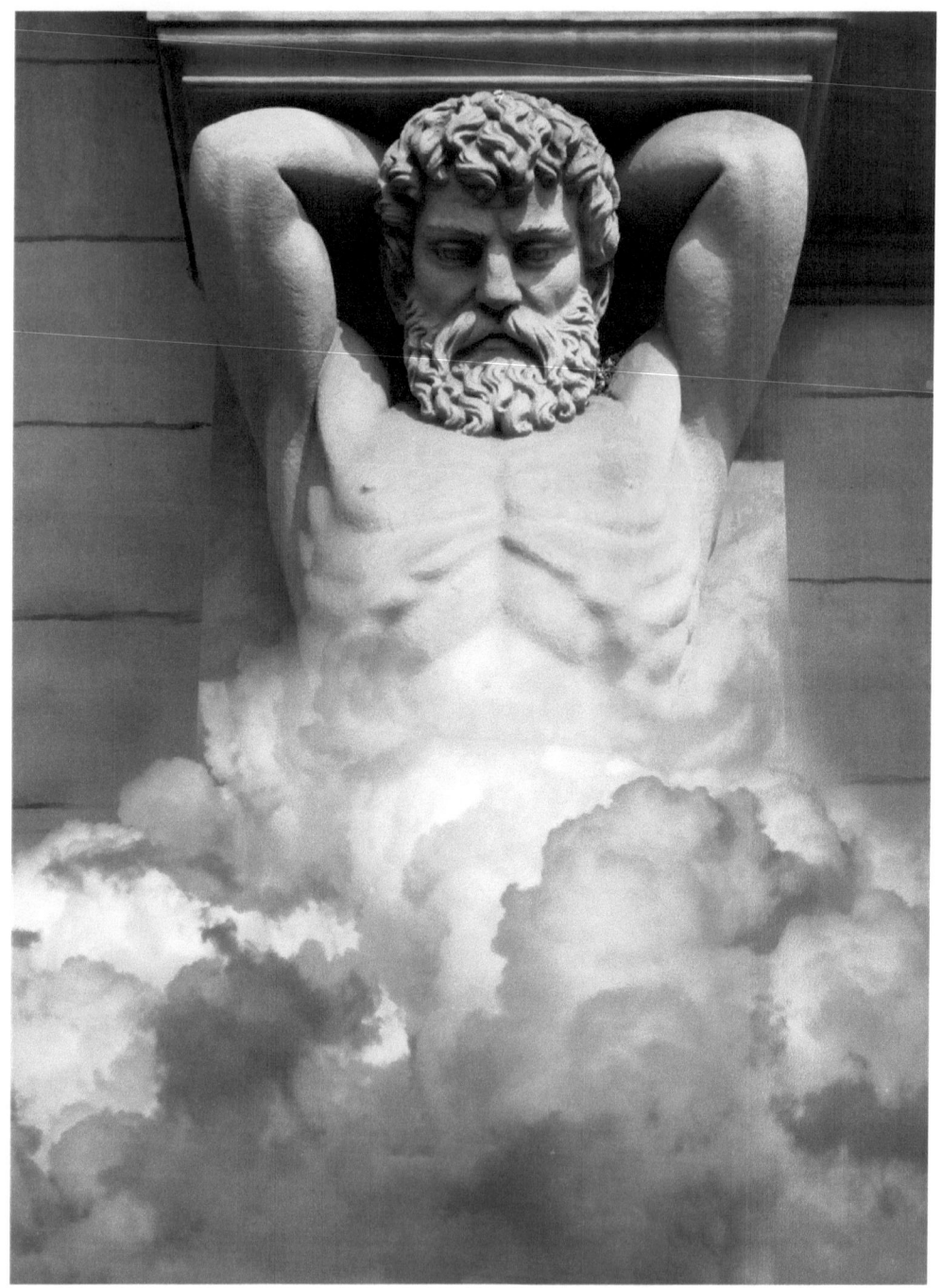

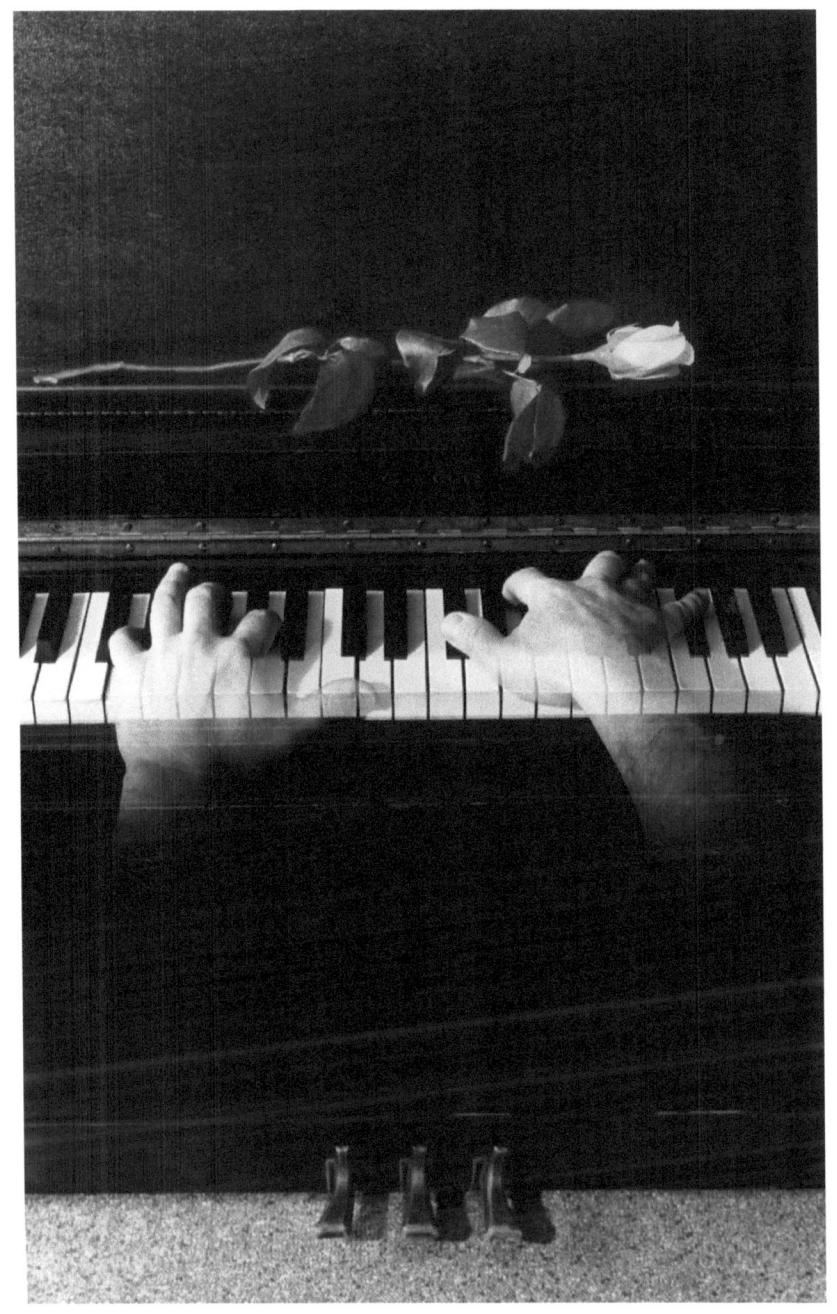

Phantom

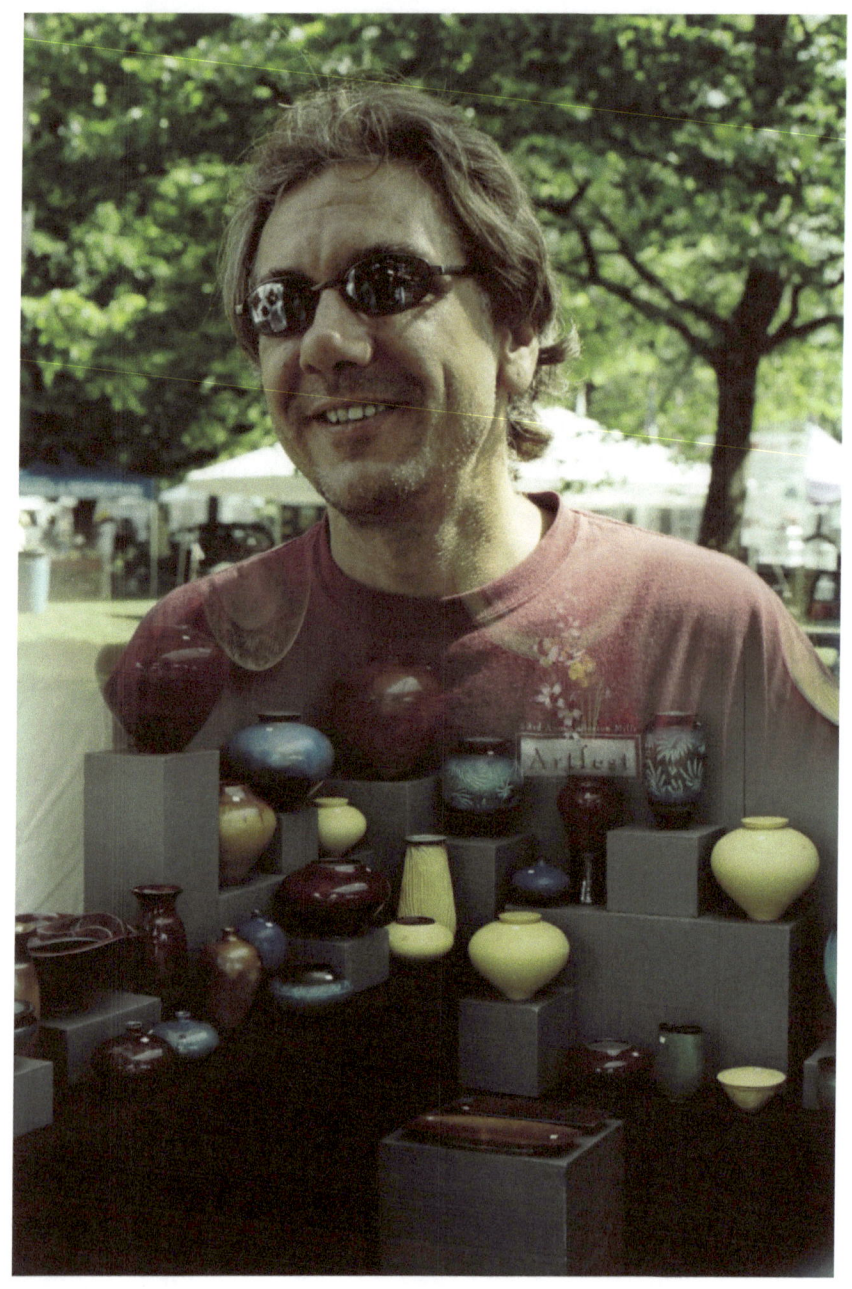

Paul

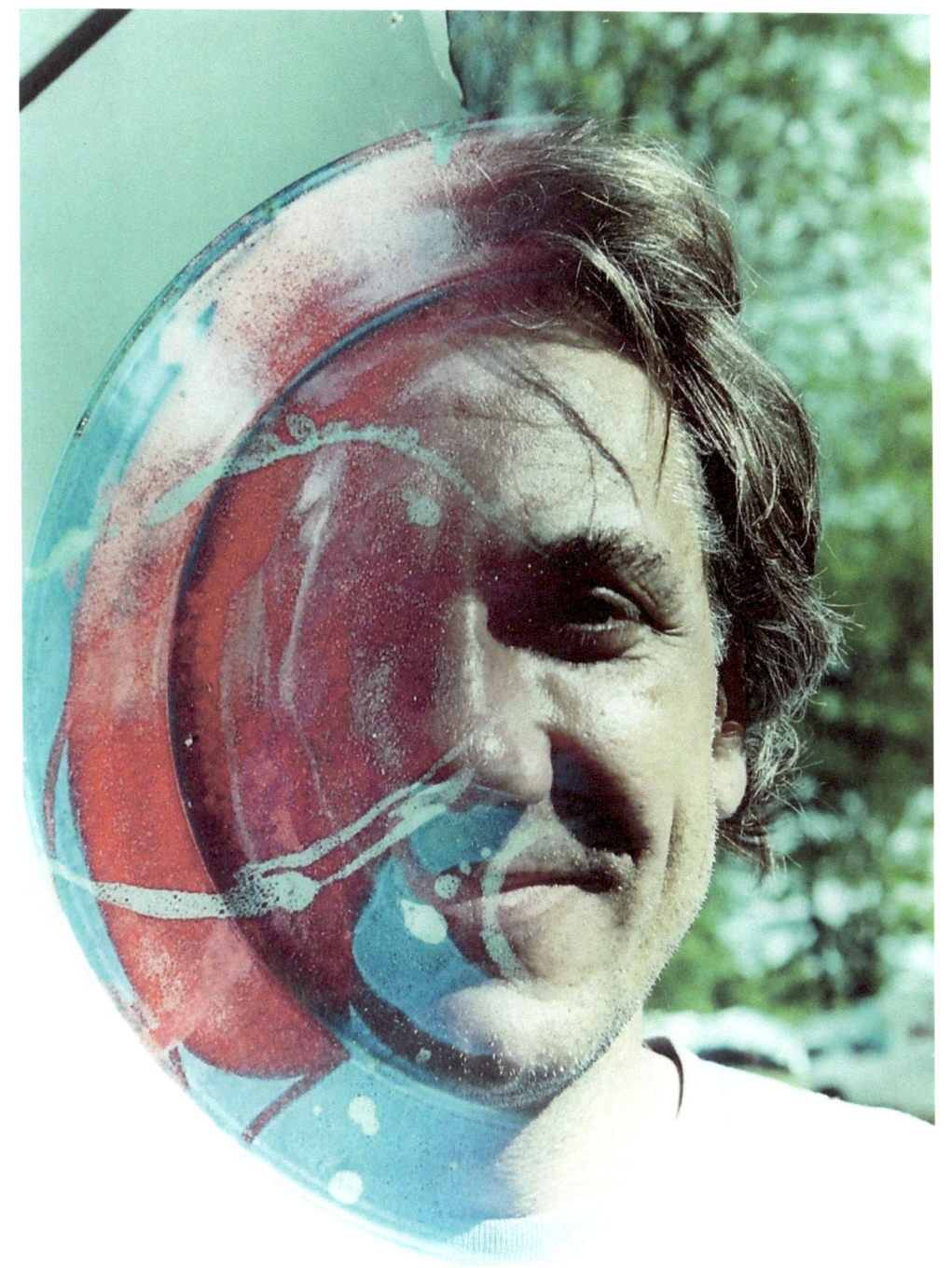

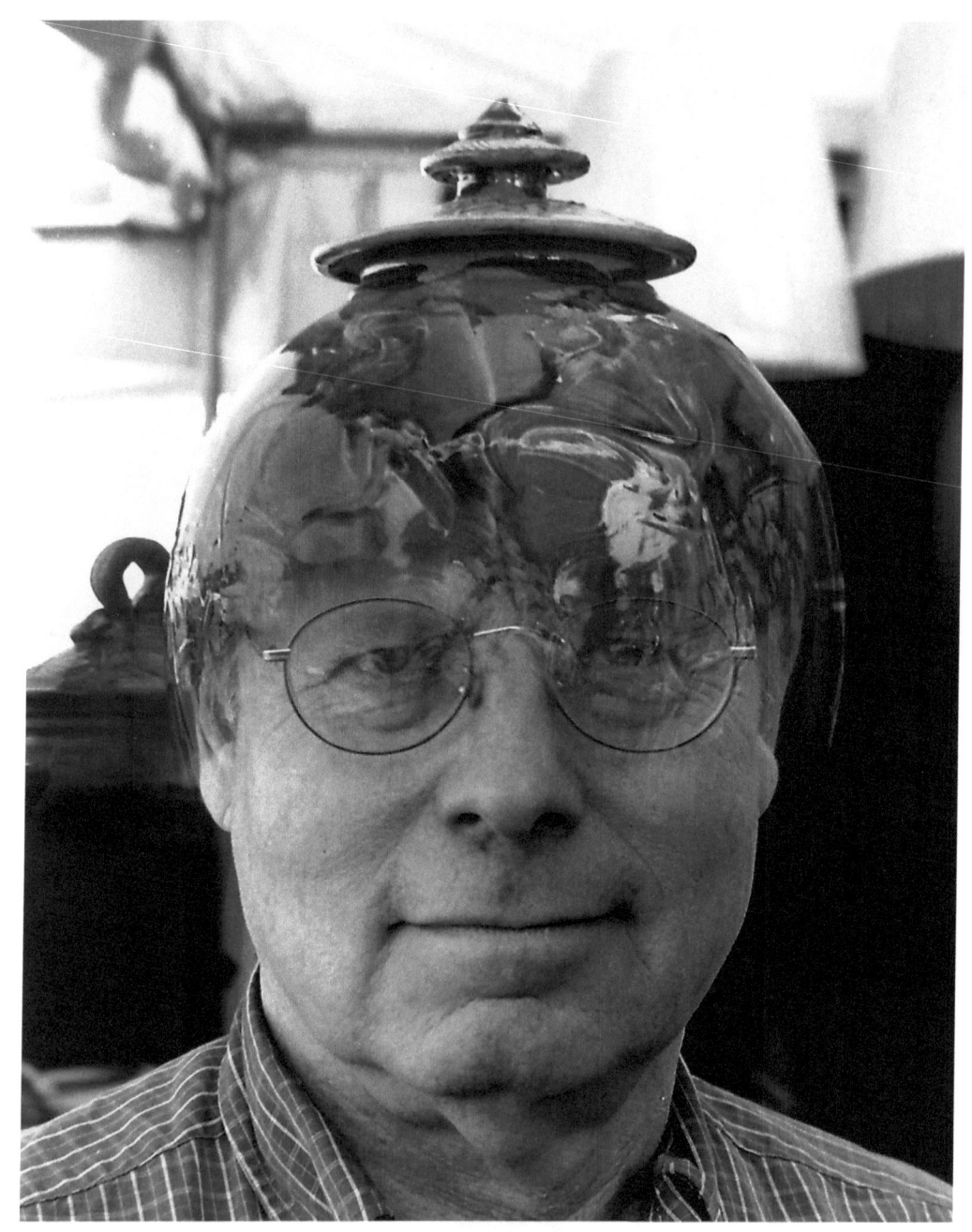

Jim

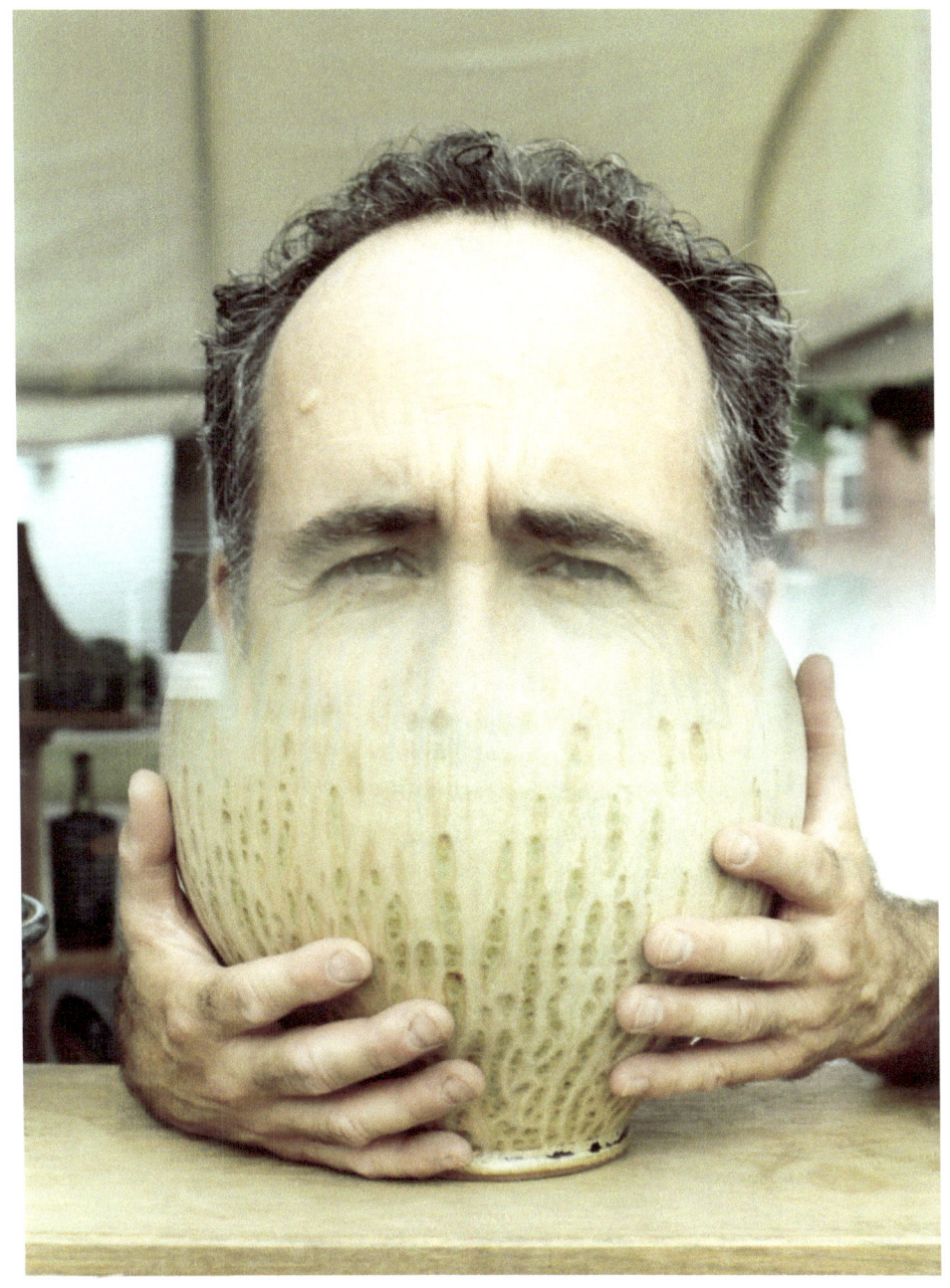

Greg

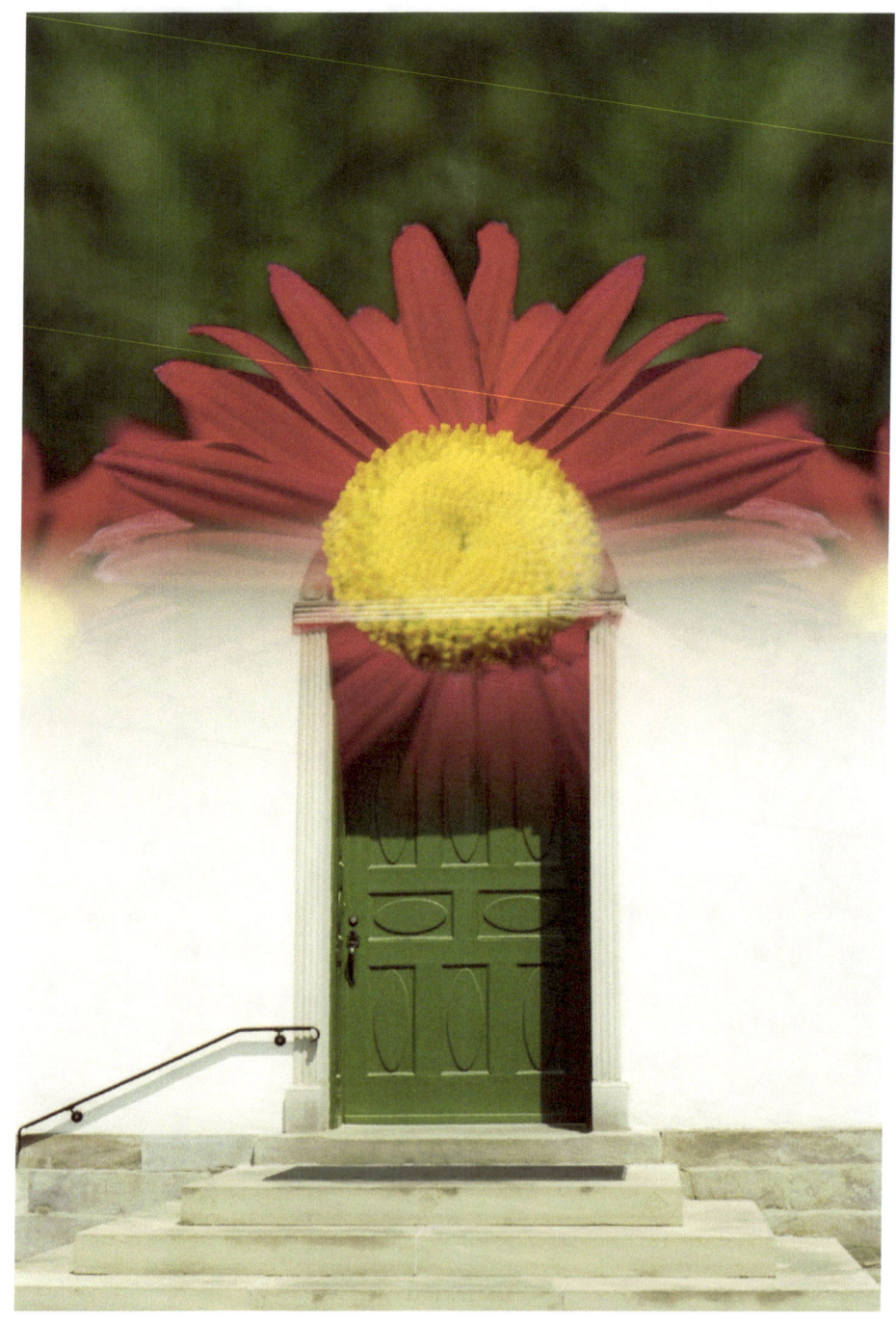

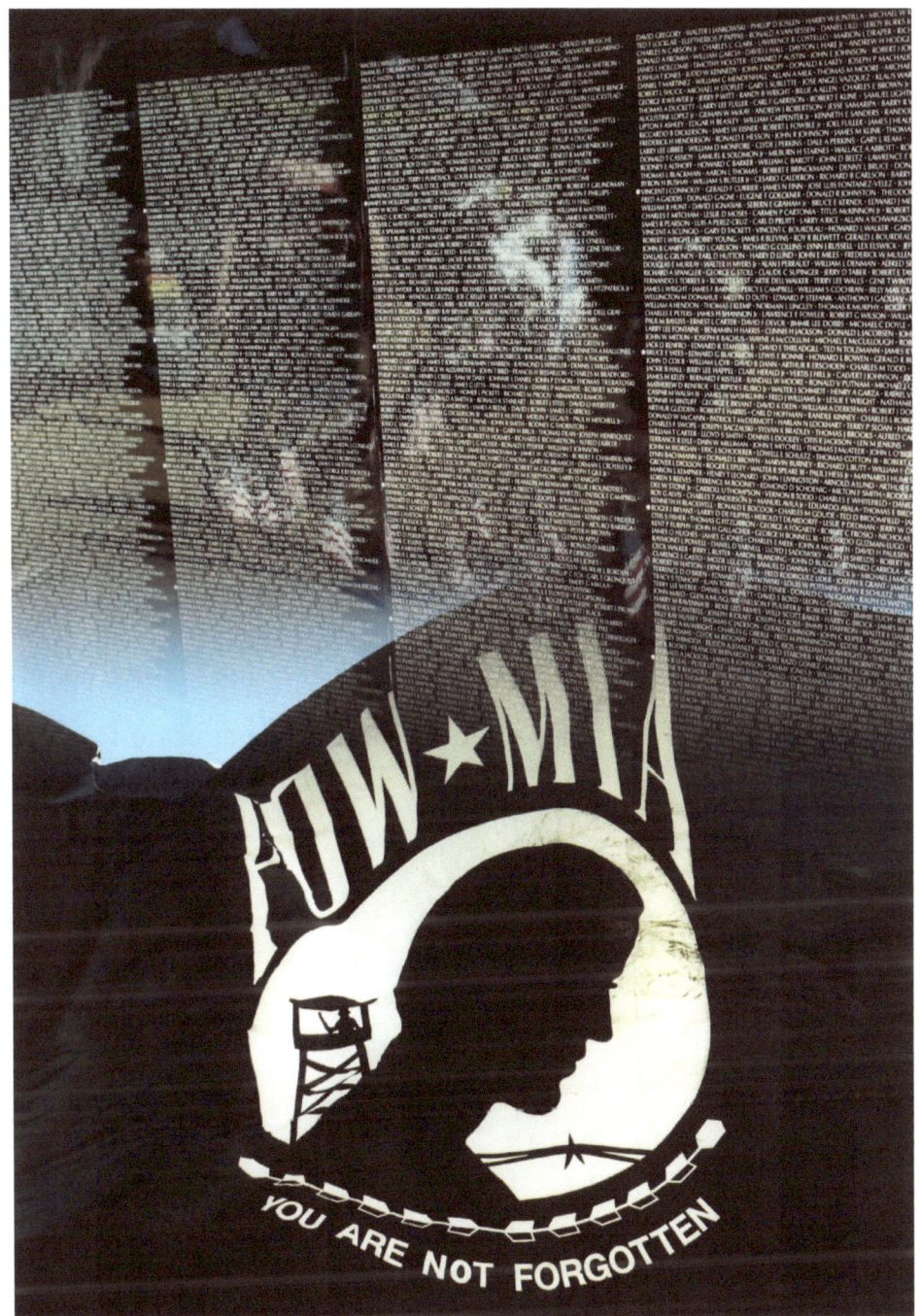

Ideas

Most of us want to make the world a better place. That's my definition of sanity. I thought for a while that I could make photographs that would be a force for social and environmental justice. Now I think injustice is more an institutional problem than a product of the social consciousness. Be that as it may, I'm fairly certain that these images don't make the world a worse place.

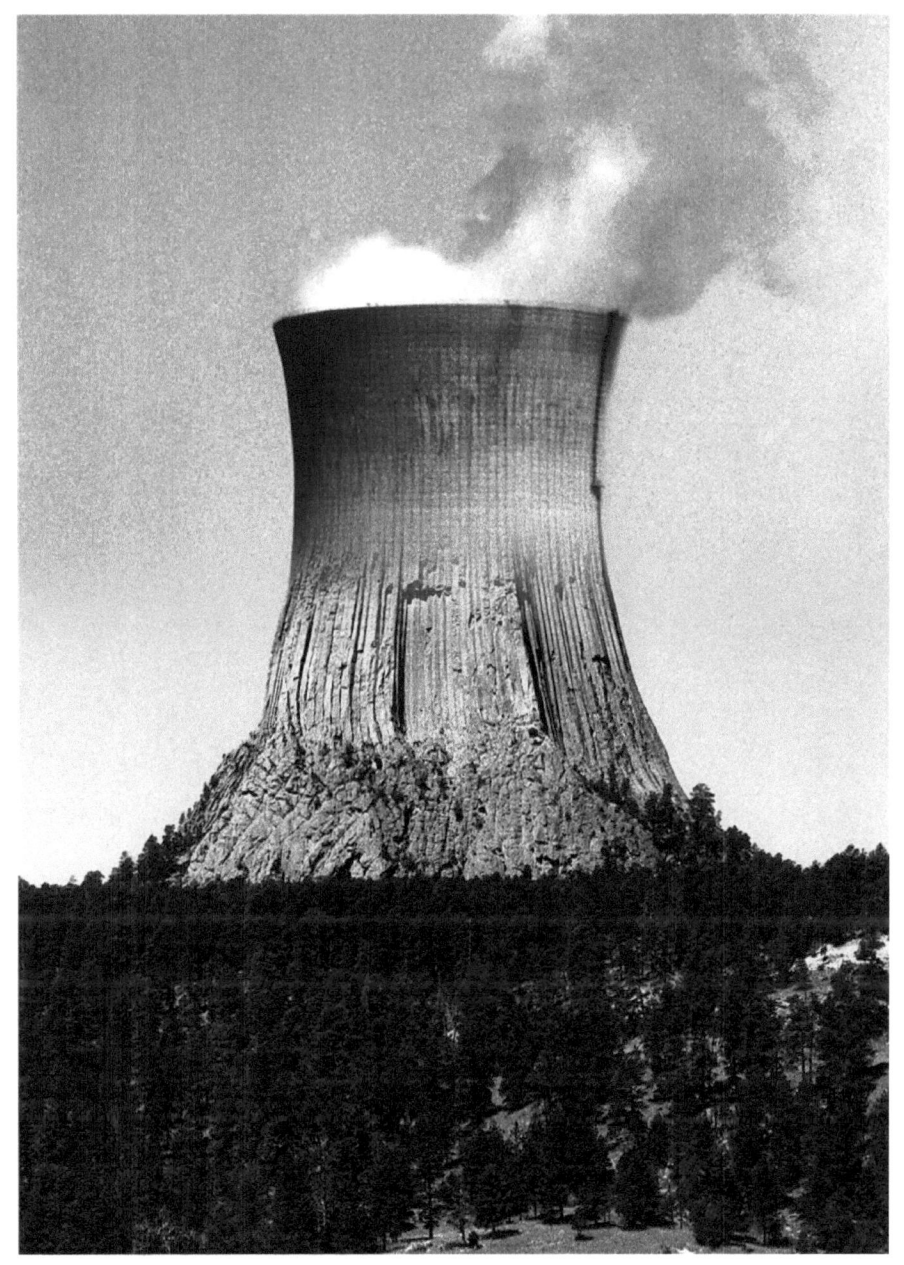

Devil's Tower

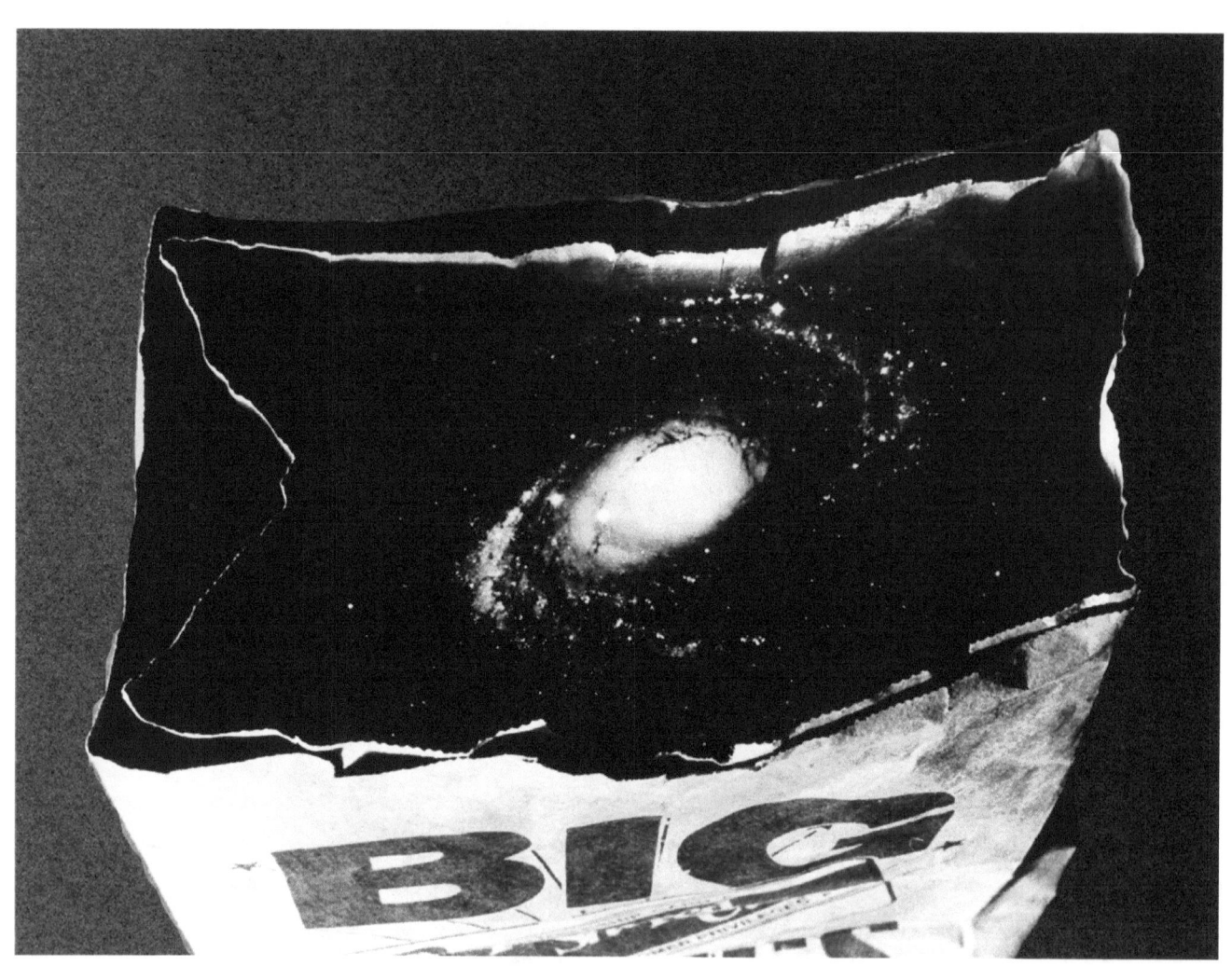

Big Bag Theory

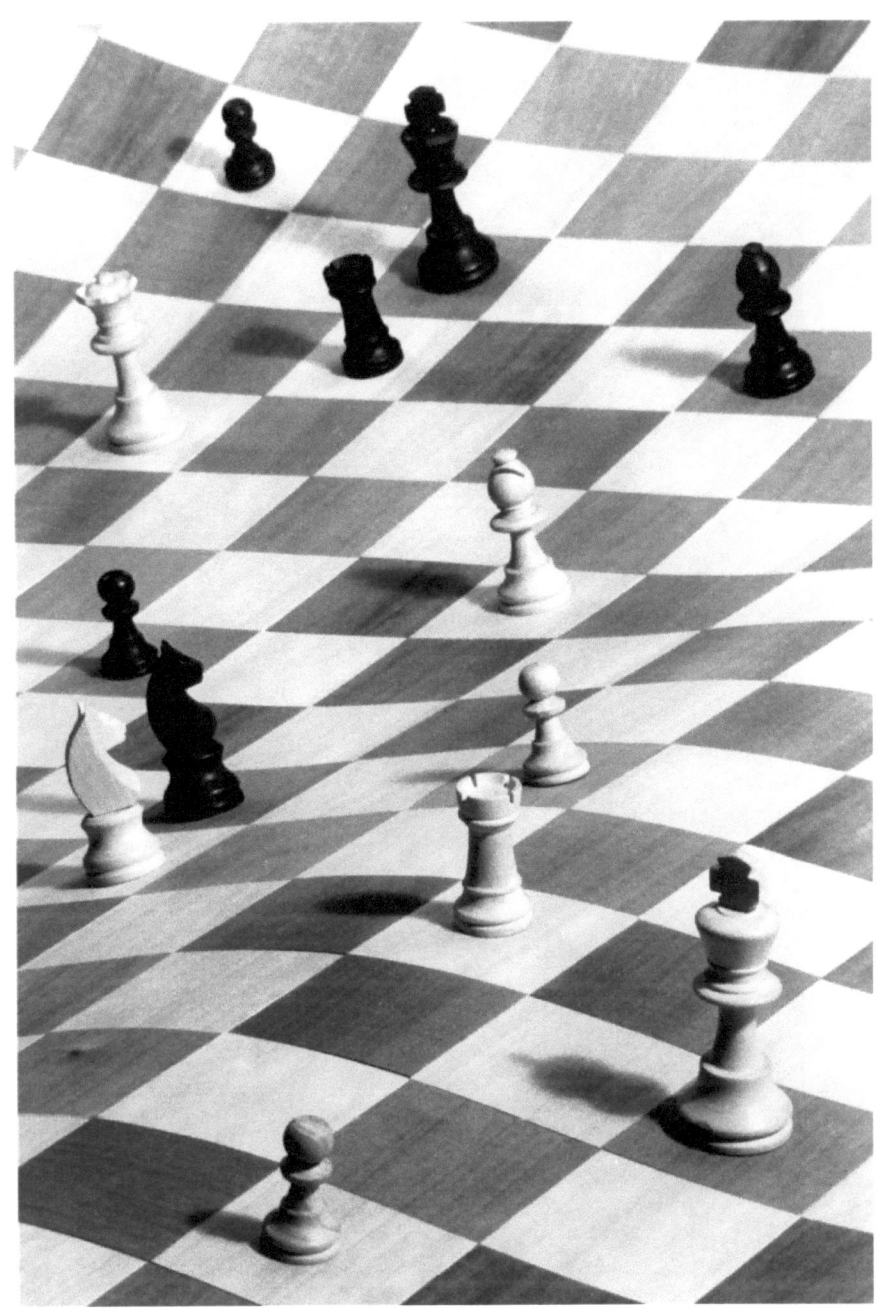

Level Field

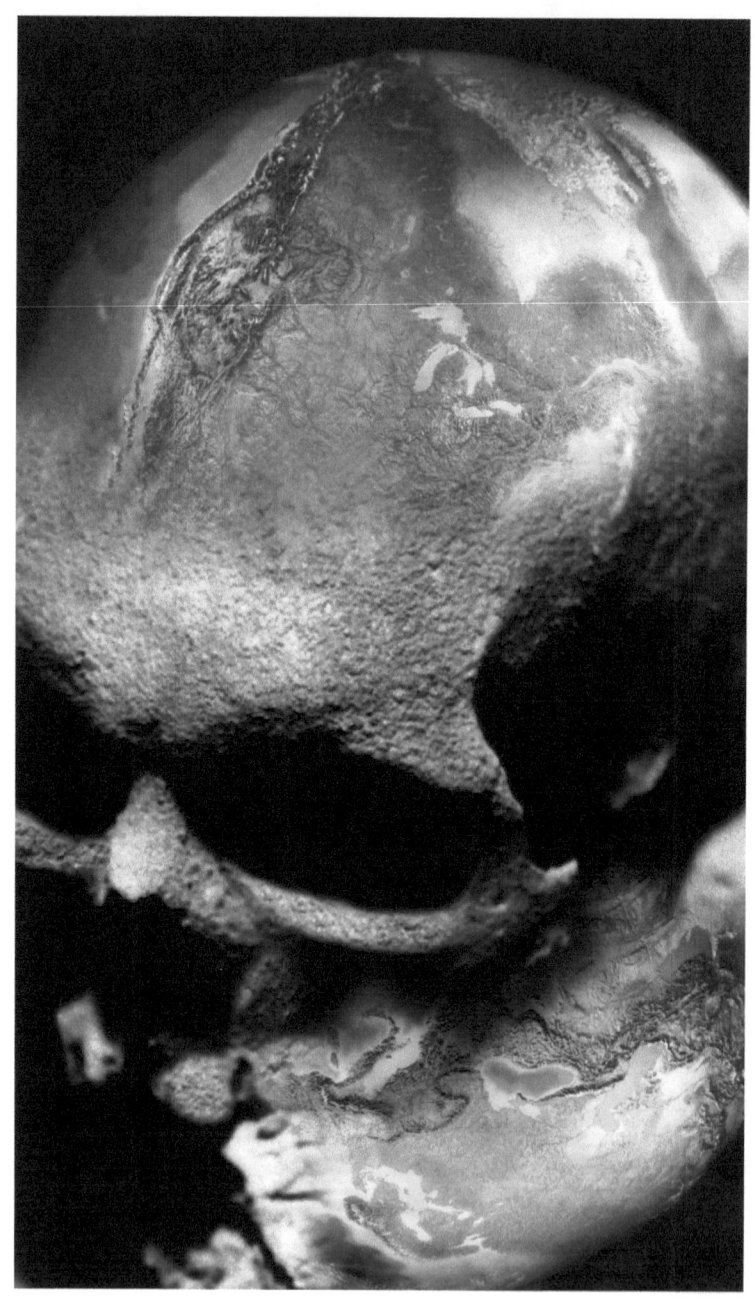

Dying Planet

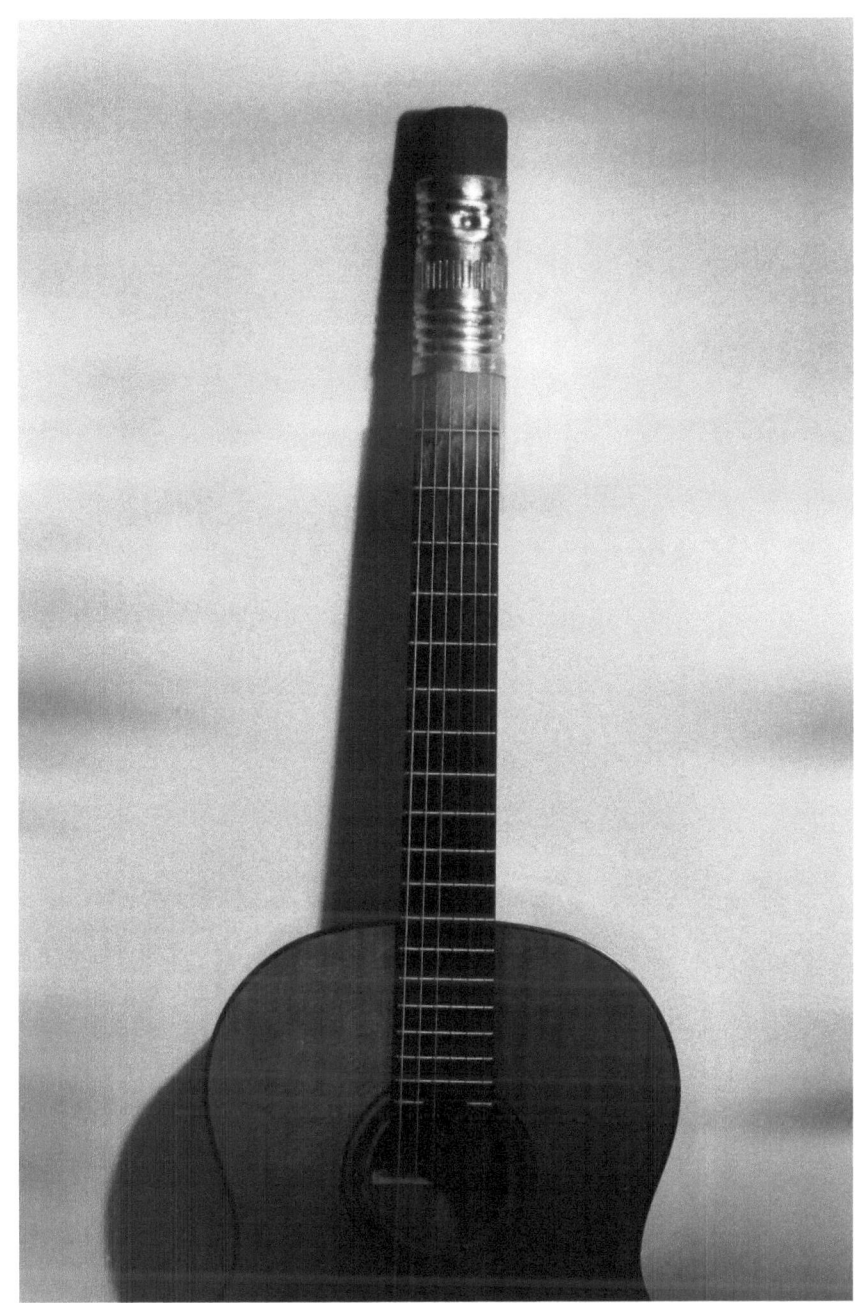

Practice Guitar

Working Artist

I've been a working artist. Selling my photographs directly to the public at art fairs has helped feed, clothe, and shelter my family for many years. It's fun, too. Every summer for thirty years, I traveled around the country meeting people, visiting with other artists, and selling my art. I don't want to make that sound too easy, because, in fact, it's a lot of hard work. The art show thing was the path of least resistance for me. Other artists may be well suited to teach art, illustrate for advertising, or freelance to publications. But I'm sort of a gypsy at heart, so exhibiting at shows was exactly my cup of tea.

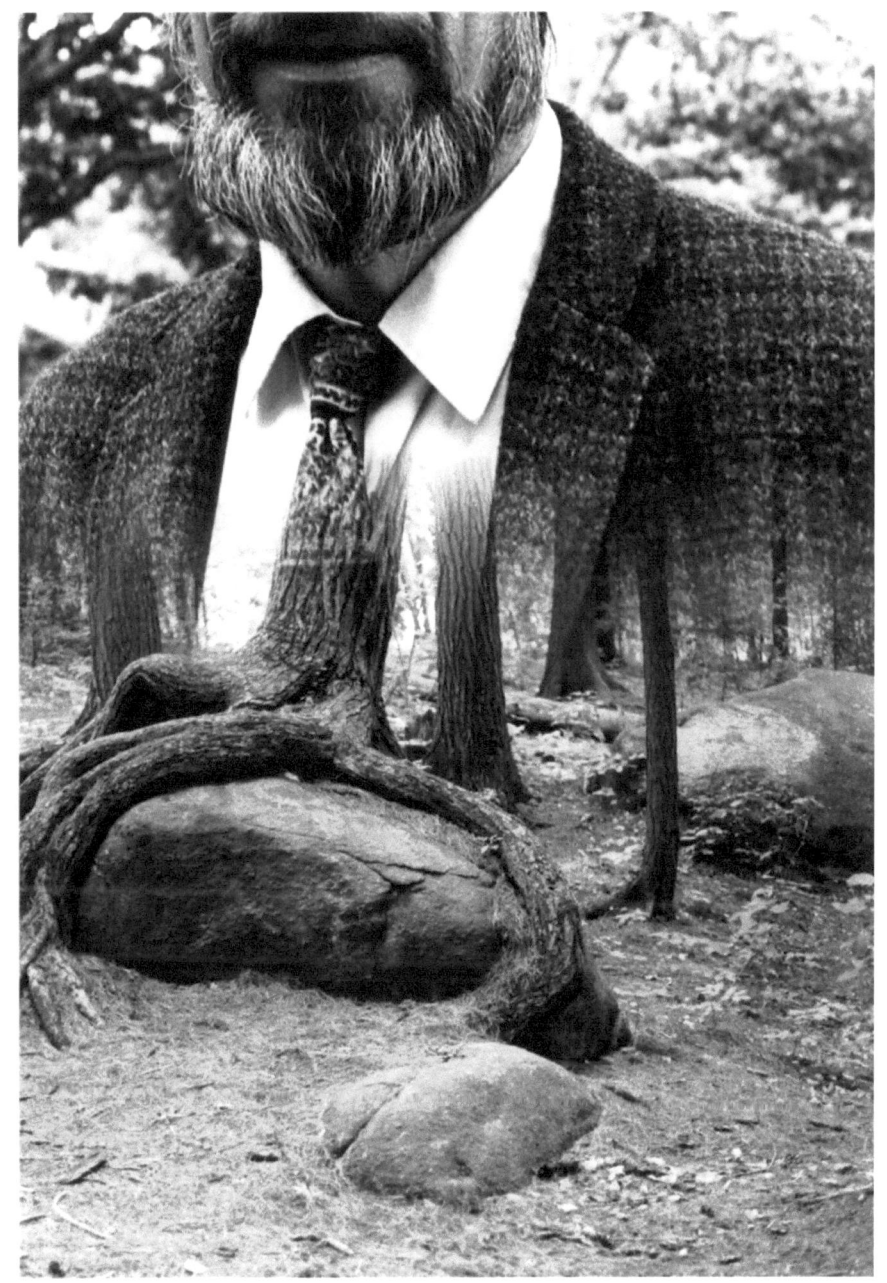

Tied Down

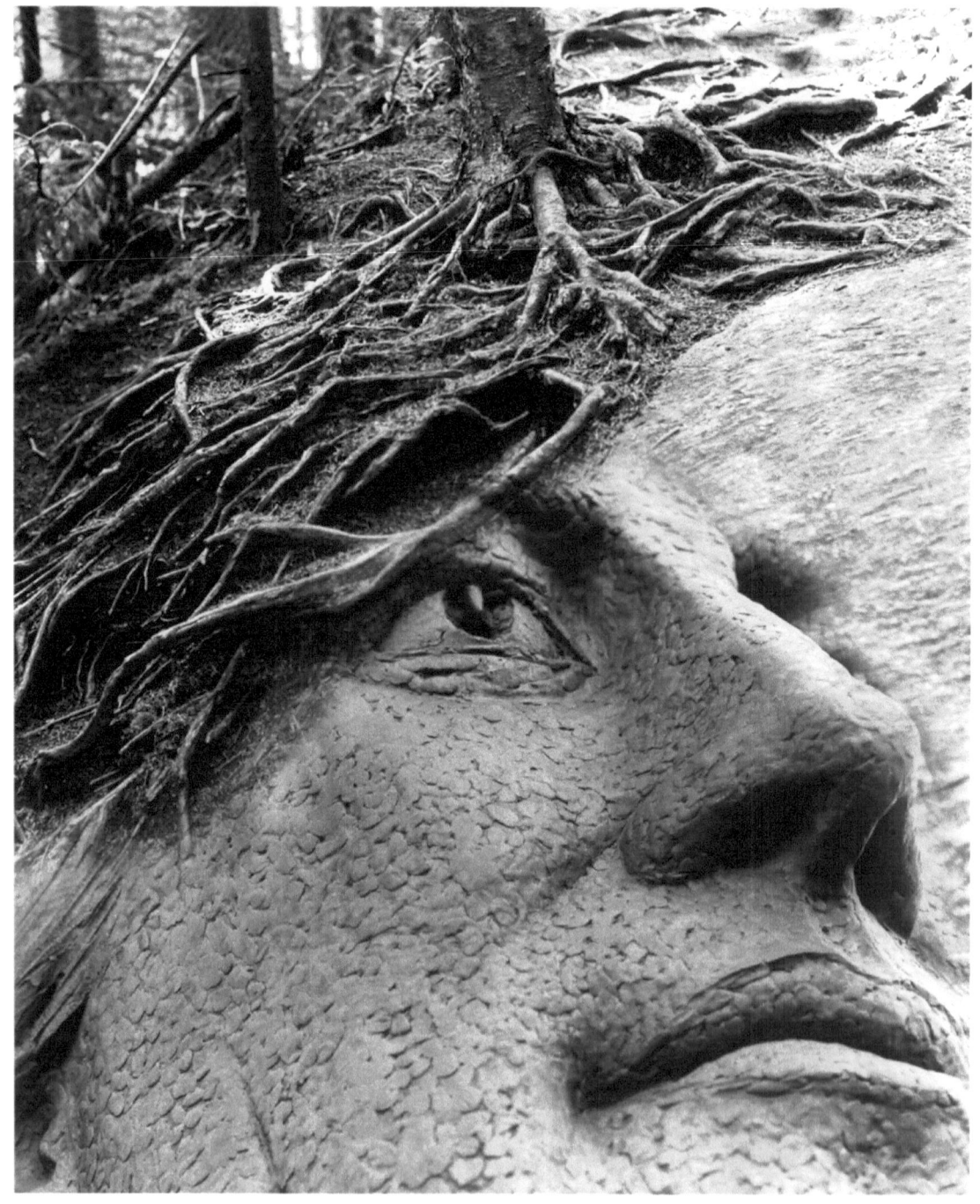

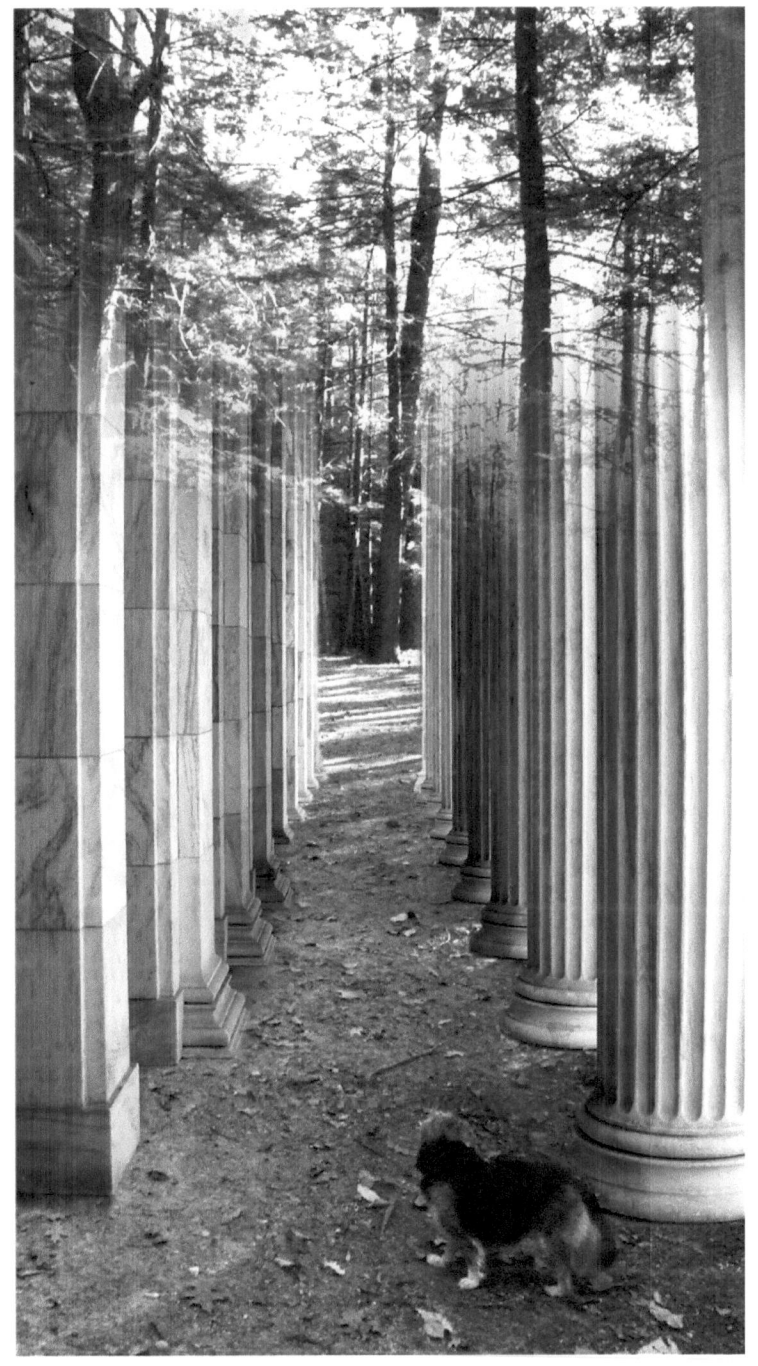

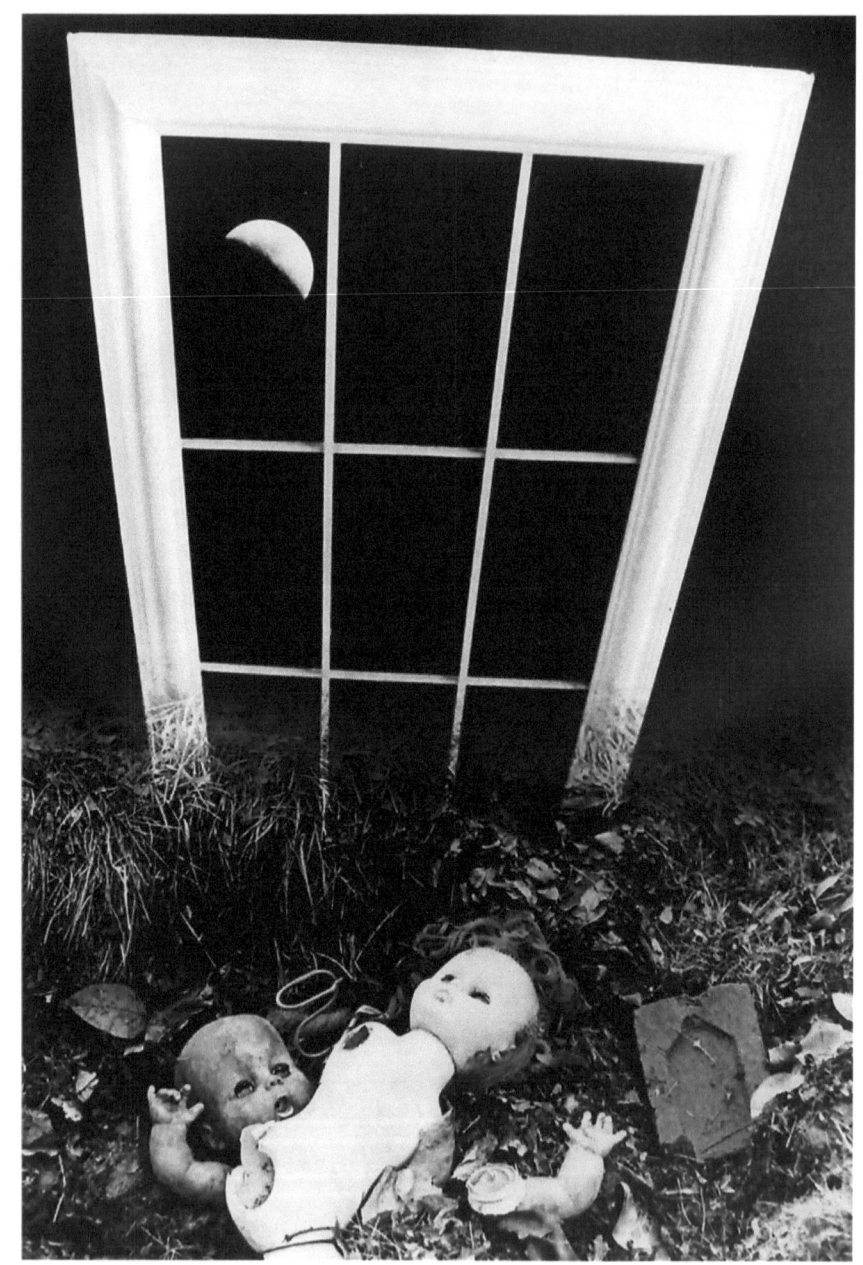

Halloween

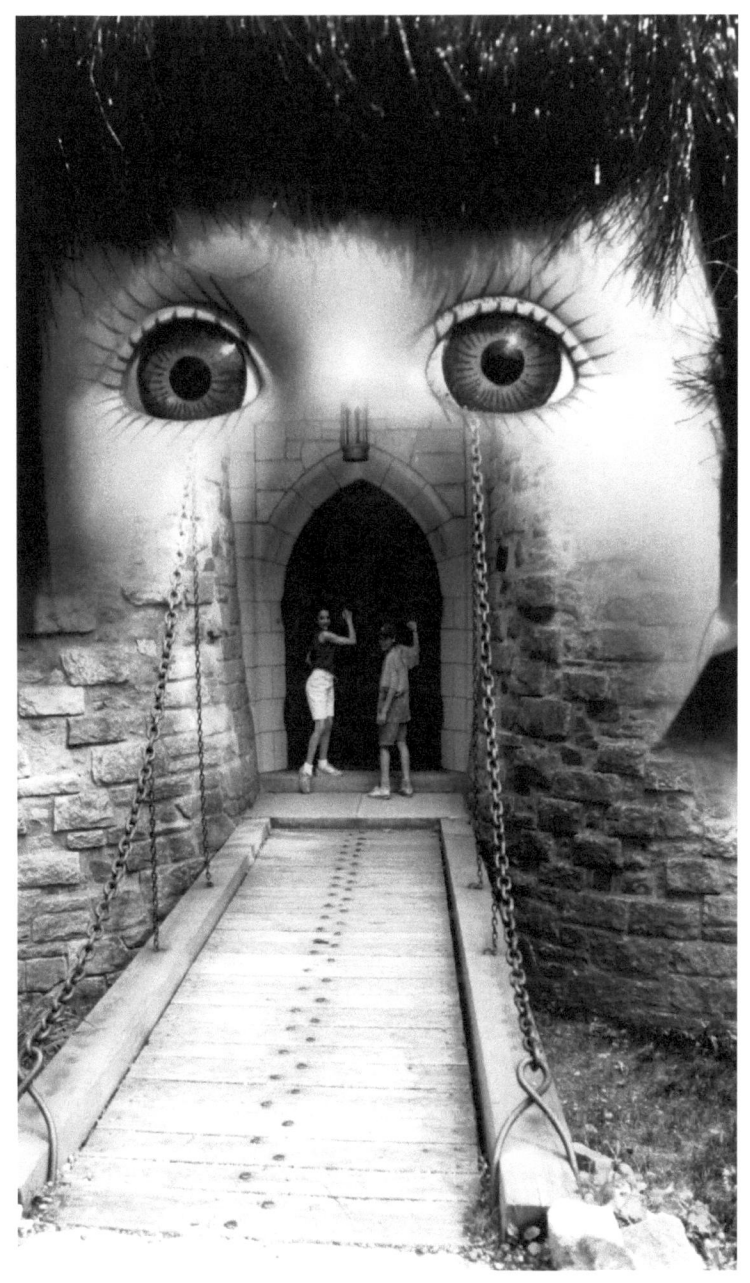

Uncle Rick's Funhouse

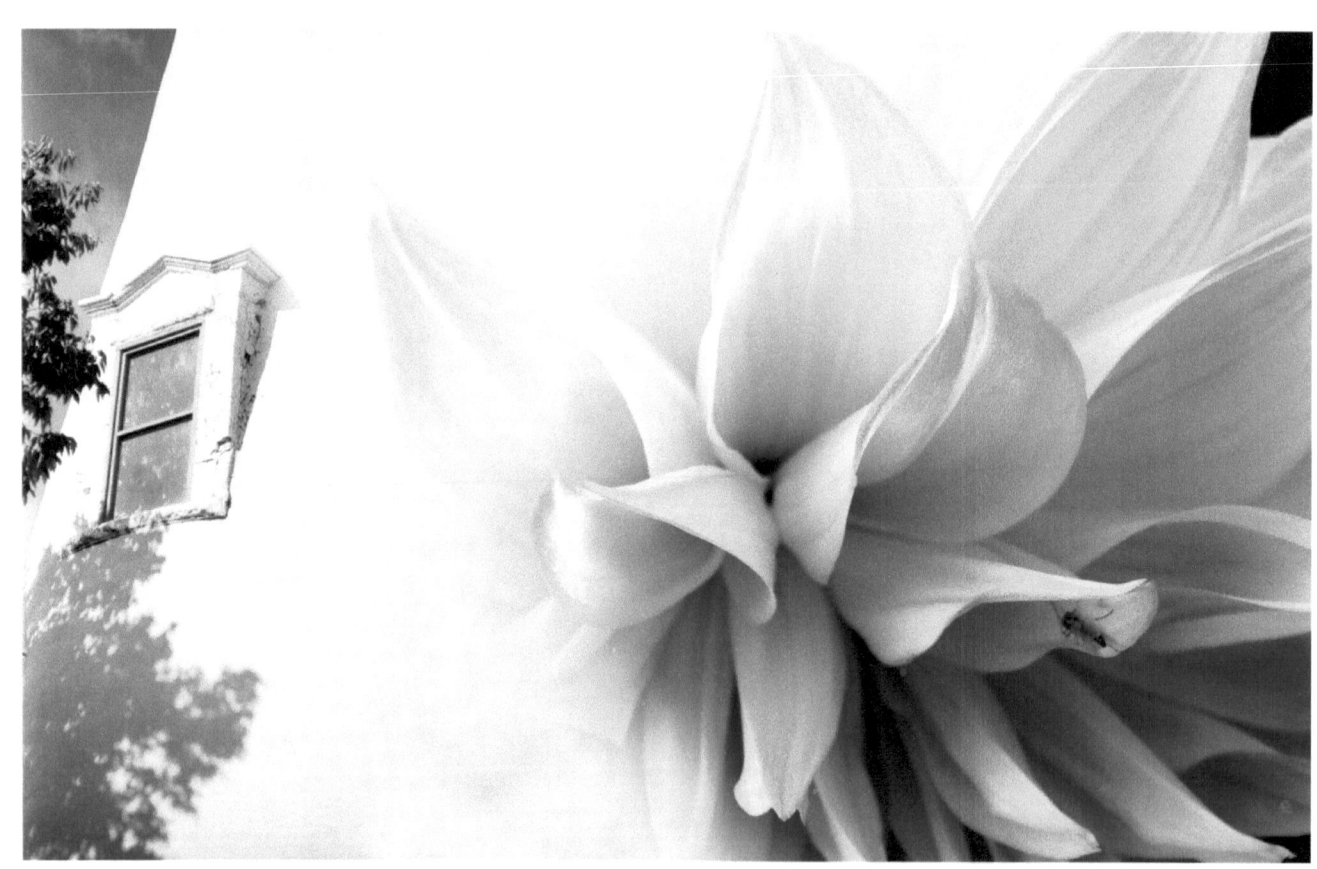

Lightroom

My darkroom is no longer dark. The sinks and enlargers have been replaced by digital imaging equipment. There are windows I can open when it's warm to enjoy a fresh breeze, instead of the eye burning chemicals of the past. These are huge changes that seemed to happen over a short period of time. I am mostly positive about the transformation, but a little sad that the skills I spent years learning are now irrelevant. As Buddha told us, everything changes. Sometimes I look out my darkroom windows at the seasons and passersby and wonder what's next.

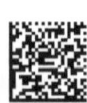
www.ingramcontent.com/pod-product-compliance
Lightning Source LLC
Chambersburg PA
CBHW050942200526
45172CB00020B/498
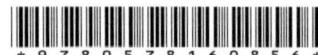